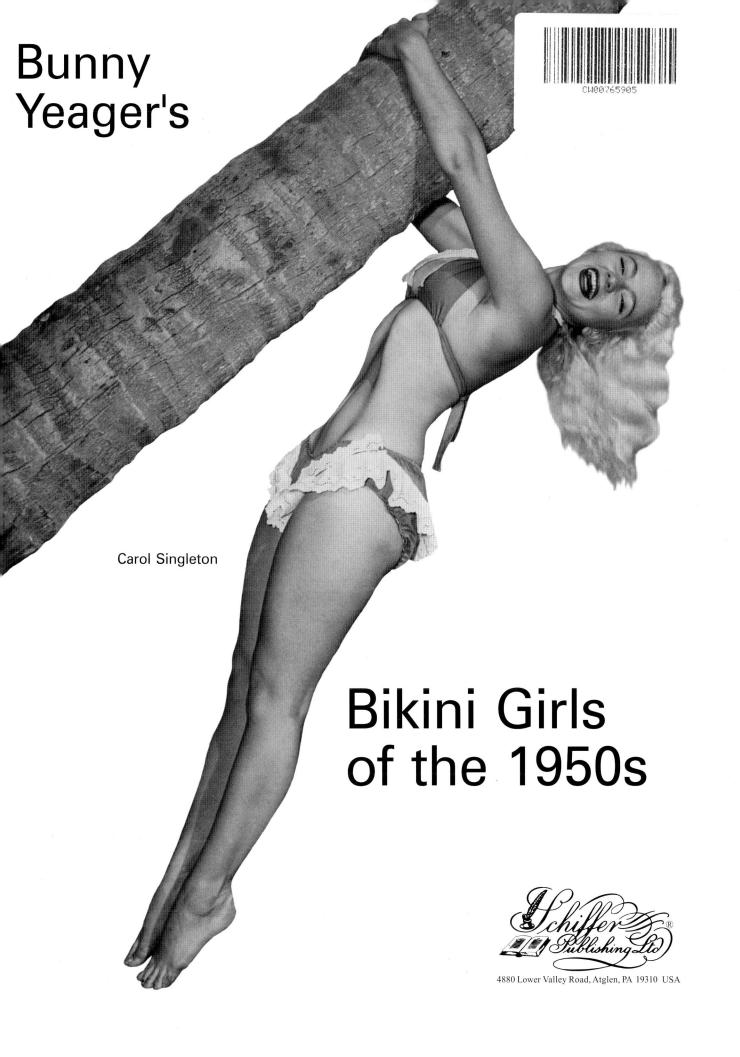

Other books by Bunny Yeager:

Photographing Girls in Jamaica
Bunny's Bikini Beauties
Bunny's Honeys
Betty Page Confidential
Bunny Yeager's Postcard Book
How I Photograph Nudes
How I Photograph Myself
100 Girls
Camera in Mexico
Camera in Jamaica
Bunny Yeager's New Photo Discoveries

Bunny Yeager's Famous Models
Fifty New Models
How to Take Figure Photos
Bunny Yeager's Photo Studies
How to Photograph the Figure
ABC's of Figure Photography
The Art of Glamour Photography
Photographing the Female Figure
Drawing the Human Figure Using Photographs

For information about ordering photographs by Bunny Yeager, write to her at 9301 N.E. 6 Avenue, Suite B201, Miami, FL 33138 • (305) 757-8978

Front cover photo: Legendary pin-up model,
Bettie Page, posing on the roof top of the Sea Gull Hotel, Miami Beach, in 1954
Title page photo: Carol Singleton

Library of Congress Cataloging-in-Publication Data

Yeager, Bunny.

Bunny Yeager's bikini girls of the 1950s / by Bunny Yeager.
p. cm.
ISBN 0-7643-2002-5 (Paperback)

1. Glamour photography--History--20th century. 2. Photography of women. 3. Bikinis--Pictorial works.
4. Yeager, Bunny. I. Title.
TR678. Y432297 2004
779'.24--dc22
2003023079

Copyright © 2004 by Bunny Yeager

All rights reserved. No part of this work may be reproduced or used in any form or by any means—graphic, electronic, or mechanical, including photocopying or information storage and retrieval systems—without written permission from the publisher.

The scanning, uploading and distribution of this book or any part thereof via the Internet or via any other means without the permission of the publisher is illegal and punishable by law. Please purchase only authorized editions and do not participate in or encourage the electronic piracy of copyrighted materials.

"Schiffer," "Schiffer Publishing Ltd. & Design," and the "Design of pen and ink well" are registered trademarks of

"Schiffer," "Schiffer Publishing Ltd. & Design," and the "Design of pen and ink well" are registered trademarks Schiffer Publishing Ltd.

> Designed by Bunny Yeager Layout by Bonnie M. Hensley Type set in Zurich BT

> > ISBN: 0-7643-2002-5 Printed in China

Published by Schiffer Publishing Ltd. 4880 Lower Valley Road Atglen, PA 19310 Phone: (610) 593-1777; Fax: (610) 593-2002 E-mail: Info@schifferbooks.com

For the largest selection of fine reference books on this and related subjects, please visit our web site at **www.schifferbooks.com**We are always looking for people to write books on new and related subjects. If you have an idea for a book please contact us at the above address.

This book may be purchased from the publisher. Include \$3.95 for shipping. Please try your bookstore first. You may write for a free catalog.

In Europe, Schiffer books are distributed by
Bushwood Books
6 Marksbury Ave.
Kew Gardens
Surrey TW9 4JF England
Phone: 44 (0) 20 8392-8585; Fax: 44 (0) 20 8392-9876
E-mail: info@bushwoodbooks.co.uk
Free postage in the U.K., Europe; air mail at cost.

Bunny Yeager, author-photographer

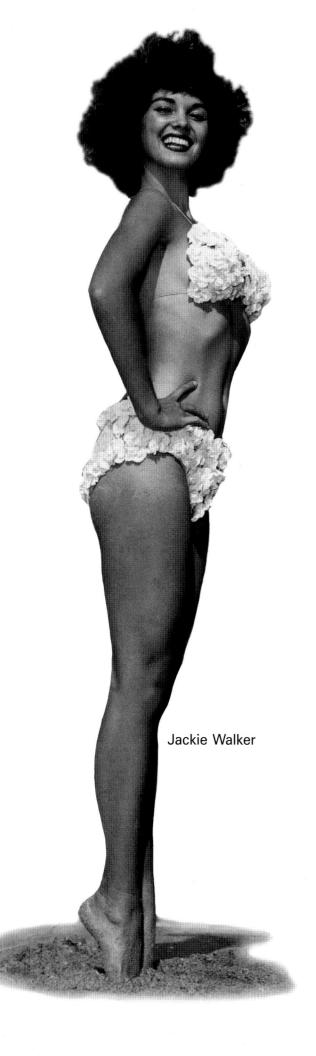

Contents

About the Author The 1950s: "The Good Life" 14 Maria Stinger, 22 Diane Webber, 24 Lori Shea, 26 Bettie Page, 28 Lisa Winters, 30 Joyce Nizzari, 32 Carolyn Kelly, 34 Eleanor Lucky, 36 Denise Lamont, 38 Marcella Patrick, 39 Mara Lindsey, 40 Audi Ragona, 41 Sue James, 41 Terry Shaw, 42 Chris Mara, 44 Sharon Knight, 46 Lana Bashama, 48 Debbie Norris, 49 Carol Jean Lauritzen, 50 Myrna Weber, 52 Lynn Brooks, 54 Gladys Rogers, 55 Dolly Doyle, 56 Eva Sloan, 57 Kathleen Stanley, 57 Lillian Bell, 58 Carol Blake, 60 La Raine Meeres, 62 Marcia Valibus, 64 Domingue Chappelle, 66 Patti Patelle, 68 Pat Stanford, 69 Sandy Fulton, 70 Jackie Walker, 71 Ginger Meadows, 72 Virginia Remo, 73 Julia Saxon, 73 Nanci White, 74 Carolyn Lee, 76 Yvonne Fredricks, 77 Bonnie Carroll, 78

Julie Padilla, 80 Jennie Lee, 82 Maritza Antoinette, 84 Pat Cooper, 86 Joan Rawlings, 88 Alta Whipple, 90 Carol Britt, 92 Jane Millar, 94 Mickie Marlo, 96 Irene Twinam, 98 Janet Johnson, 98 Una Diehl, 99 Dottie Sykes, 100 Laurie Scott, 102 Nadine Ducas, 103 Patti Simmons, 104 Charlene Mathies, 106 Linda Vargas, 108 Sally Larimer, 110 Camille Stewart, 111 Gigi Reynolds, 111 Phyllis Ursin, 111 Mary Tilghman, 112 Joanne Geary, 114 Tina Tiffany, 115 Carol Singleton, 116 Marcella Hansen, 117 Nancy Kelly, 118 Ruth Shepard, 119 Paula Casey, 120 Kevin Cornell, 120 Marlayna Scott, 121 Rebel Rawlings, 121 Suzanne Harting, 122 Cindy Lee, 123 Maryann Harrison, 124 Sara Brockett, 124 Dawn Reddick, 125 Elaine Deming, 126 Kelly Evans, 127

Index 128

Bunny Yeager

Bunny Yeager, self portrait

ABOUT THE AUTHOR

Bunny Yeager became a successful fashion and photographer's model in the late 1940s and early 1950s. She entered beauty contests and won over two dozen titles before starting to shoot photographs in 1952. She became a serious glamour photographer, selling her first photo in 1954, a magazine cover.

Her photo of Bettie Page appeared in the January, 1955 issue of *Playboy* magazine, the first of eight centerfold "Playmates" she photographed for this popular men's magazine.

In a 1959 poll taken by the Professional Photographers of America, Inc., she was chosen as "one of the top ten women" in U.S. photography. She has long been considered a top glamour photographer in a profession that is dominated by men.

Her family suggests to her that she retire and "take time to smell the roses," but she says she can't. This is her life and shooting photos of beautiful girls keeps her energy high and living a happy and purposeful life.

Bunny Yeager, self portrait

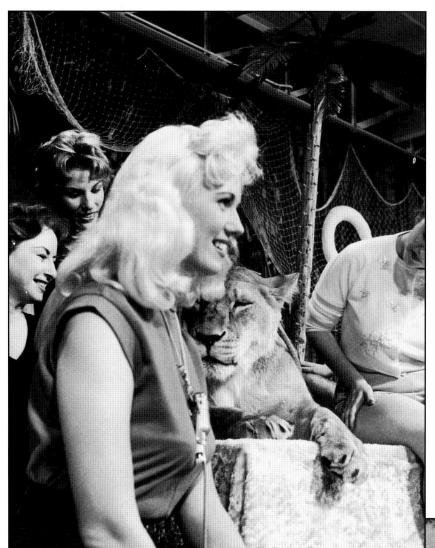

Bunny Yeager was the featured headliner at the Dallas Photo Fair in 1959. Here she is shown on stage (with mike around her neck) speaking about her work as a glamour photographer, sharing the stage with some of the beauty contestants and a friendly lioness.

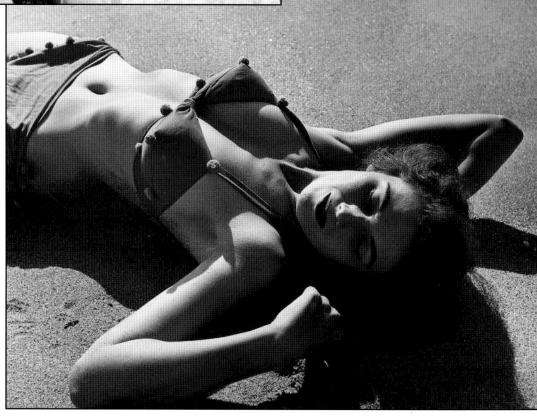

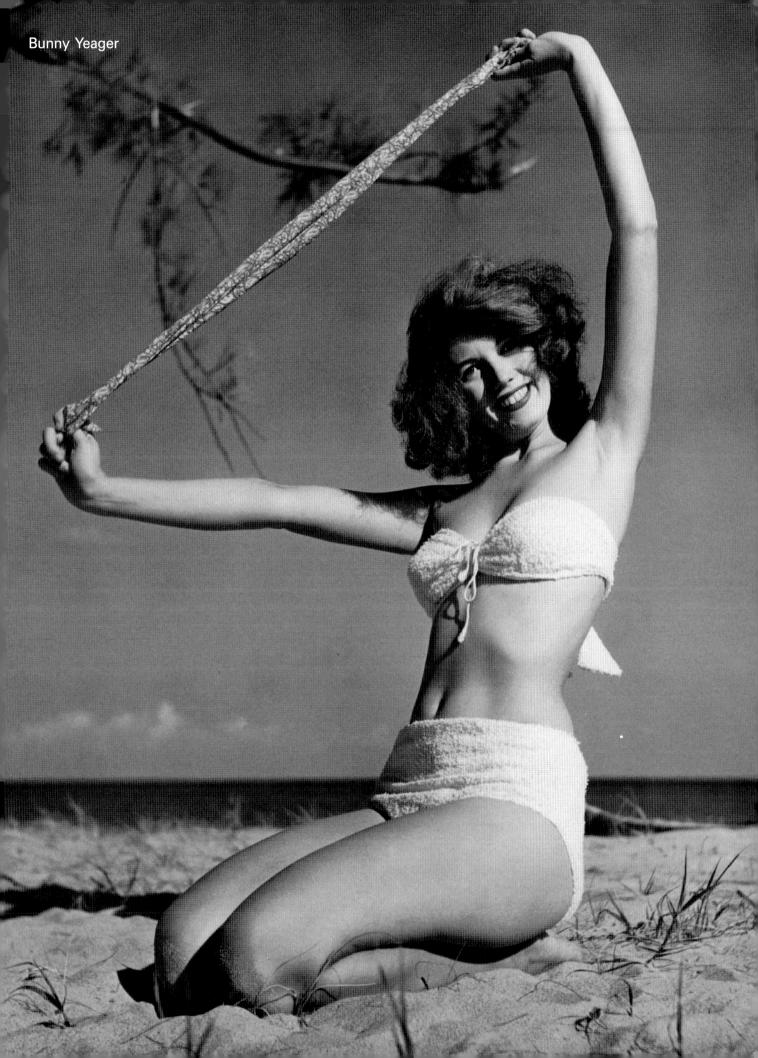

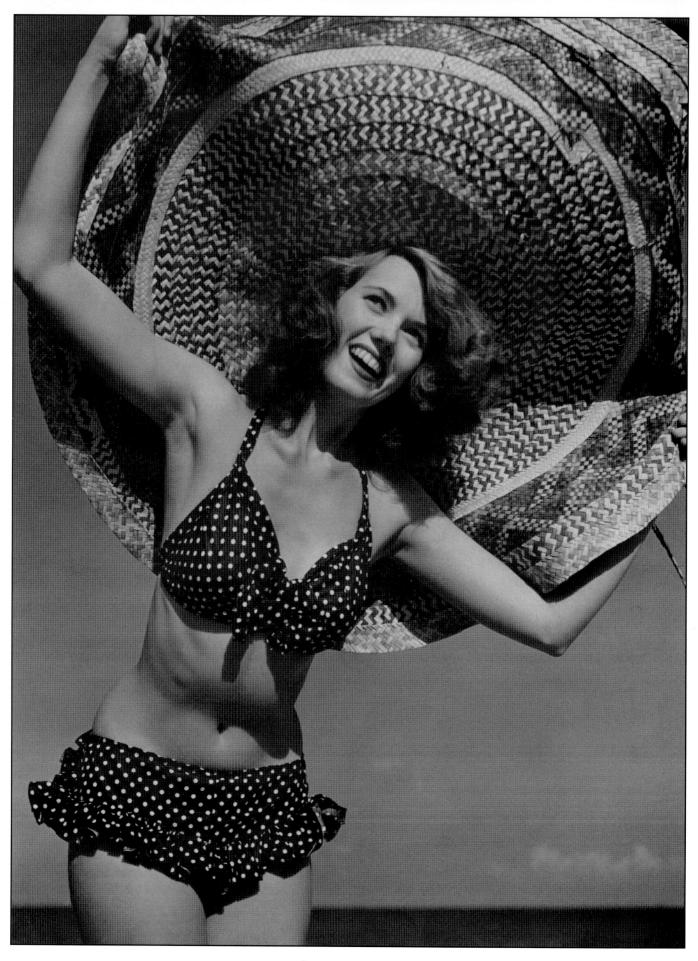

Bunny Yeager

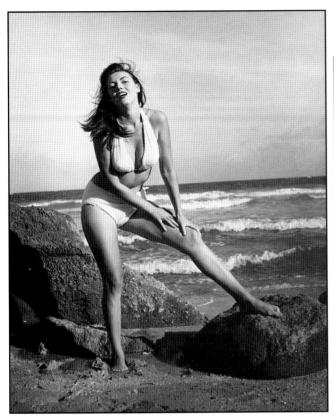

Bunny Yeager self-protraits

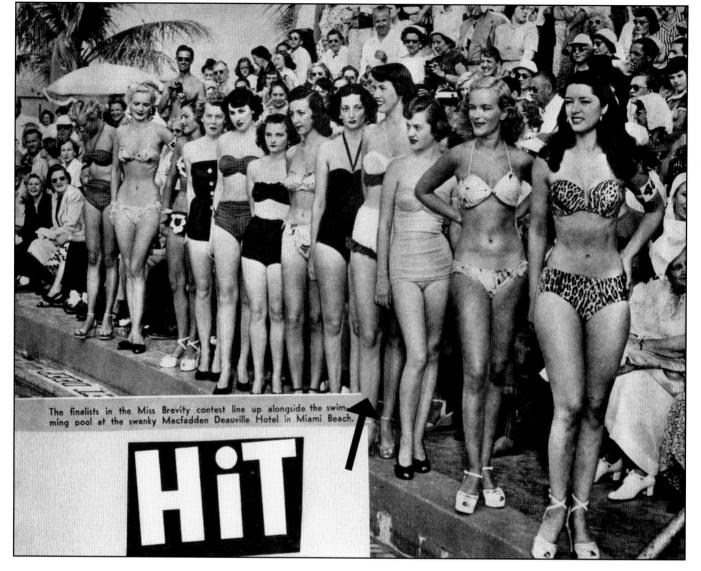

This photo was published in Hit magazine, August, 1950.

The "Miss Brevity" beauty contest was held at the Macfadden Deauville Hotel, Miami Beach in 1950. It had an Olympic-size swimming pool with bleachers around all sides for the spectators, who came prepared with cameras to check out the action. Every weekend there was a spectacular diving show and once a month, during the winter tourist season, a beauty contest was held. There was always a good turnout for the contests, usually drawing at least 30 to 40 girls. The girls had to parade around the pool in high heels. (We were so close to the spectators that there was hardly enough room for us to walk.) Study the photo. Notice the "briefness" of the bathing suits. Only a few girls were brave enough to wear the skimpiest suits.

I'm the tall girl near the middle, in my white terrycloth, homemade "bikini" with the green fringe I added to it. What were some of these contestants thinking when they arrived at a contest like this wearing an "old-fashioned" one-piece bathing suit? The two briefest suits were one-of-a-kind reproductions of the original Paris bikini, which was heavily publicized in newspapers worldwide right after World War II. All of the girls in the photograph were the semi-finalists. The girl on the far right was the winner, which I believe was fair. Her suit came from a designer shop in the hotel. I would have liked to win, but I couldn't, because my suit was not one of the briefest. The girl who won, not only had a brief suit, she was very pretty too.

Nanci White, Carol Britt, and Kathleen Stanley pose for a Miami Beach motel advertisement. Unfortunately a guest walked in behind our set-up, and ruined this picture, which is why I have it. I had to give all my other shots to the ad agency.

The 1950s: "The Good Life"

The 1950s were "sweet," and prosperity and the good life reigned. It was one of the best times to be alive, not only for me, but for most people living in the U.S. whatever their age.

Servicemen and women coming home from World War II in 1945 wanted to get back to enjoying a normal life and the freedom for which they had just fought. Because of the G.I. Bill, more than one million ex-servicemen were able to attend college and further their education. Now they could live their dream of marrying their high school sweetheart, having two or three children, and settling down in a little cottage with a white picket fence. The G.I. Bill also entitled them to buy a two-bedroom, one-bath house in a new subdivision with little or no money down.

Along with this new level of prosperity, there was a new sense of freedom. The 1950s witnessed a growing sense of sexual freedom reflected in people's lives and in the culture as a whole, including a new openness in the press.

Perhaps this was no more evident than on the nation's beaches. Two-piece bathing suits were worn in the 1940s, but it wasn't until the 1950s that a real bikini suit was seen. Their popularity rose in the late 1950s and early 1960s.

I started shooting photographs in 1952 and sold my first photograph in 1954 of a girl in a leopard print bikini I made myself. Almost all of the bikinis in this book are bathing suits I designed and sewed myself. My ability to do this helped me sell photographs to men's magazines and compete with male photographers. They didn't know how to sew!

My husband and I got our first TV set in 1955. It was black-and-white; there were no color sets yet. We watched Elvis Presley on the Ed Sullivan Show in 1956. Elvis was only permitted on camera from the waist up because of his sexual gyrations as he sang and played his guitar. He turned "Rock and Roll" into a teenage cult religion with songs like "Blue Suede Shoes", and "Love Me Tender." Other heroes of the day were the Yankee Clipper, Joe DiMaggio, Roy Rogers, and Doris Day. Frank Sinatra, who started his career in 1944 was still popular. Science fiction was "in" as were horror comic books and "Mad" magazine.

Some TV shows I enjoyed were: "I Love Lucy," "The Honeymooners," "Phil Silvers Show," "Burns and Allen Show," and "Our Miss Brooks." Other popular TV shows were: "Dobie Gillis," "Father Knows Best," "Leave It to Beaver," "December Bride," "Mama," and "Mr. Peepers."

Among the popular quiz shows of the era was "What's My Line?' hosted by John Daly. The panel, made up of Dorothy Kilgallen, Steve Allen, Arlene Francis, and Bennett Cerf, would have to guess what the guest did for a living. The guest came out and "signed in" on a blackboard with chalk. Then words would flash on the screen telling the audience what was the guest's profession. The panel could not see the screen. The four panelists asked the guest questions to try to figure out the occupation. "What's My Line" lasted more than 17 years.

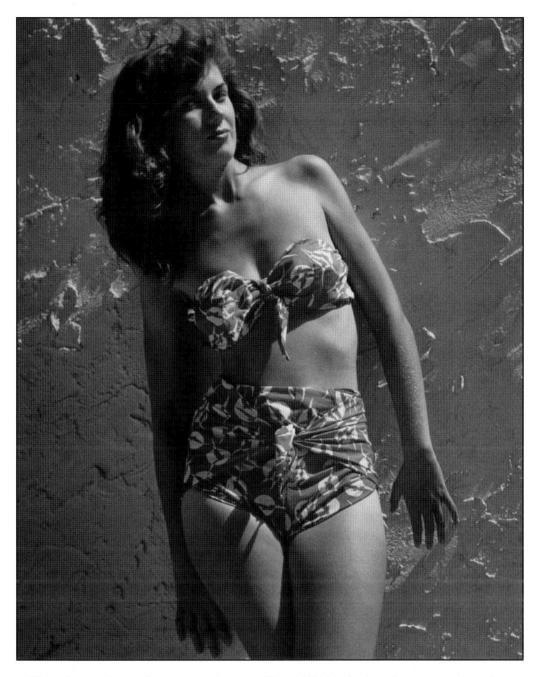

The photo above is me wearing my first bikini suit. I took some red and white print material and used it to cover a strapless bra. The bottom is "diaper style." The suit is made of 2 triangle cuts. The pointed end of the triangle was sewn together to make a crotch. One end covered the front of me and tied in the back. Then the back triangle was pulled to the front on each end and tied in the front into a loose knot. I thought it was a pretty cute suit and I liked it a lot; however, one day I wore it for Don Duffy, a Miami Beach publicity photographer. He took one look and said, "Too much material. Why don't you untie the front and the back and roll down the top of the bottom of the suit and tie it on each side to make it look smaller? I didn't have a mirror to see what I was doing, but I did as he told me and he loved it, shooting many photos of me that day. The result was unbelievable. It was used in newspapers all over the world. (I have clippings.) But, in addition it also wound up on the front cover of the newspaper "The Hurricane", the University of Miami publication which made me popular with all the male students. When my mother saw that photo, she gasped "You look like you're almost nude!" I was a little self-conscious about it all, but I liked the way I looked.

What's My Line?

I appeared on the "What's My Line?" television show in 1957. These photos of me were taken with a regular camera off the TV set as the show aired.

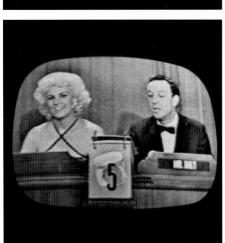

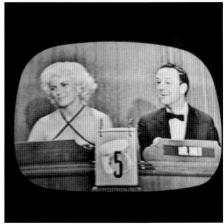

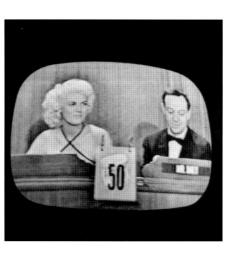

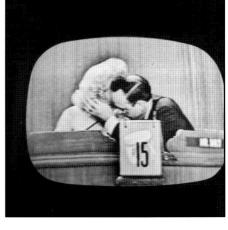

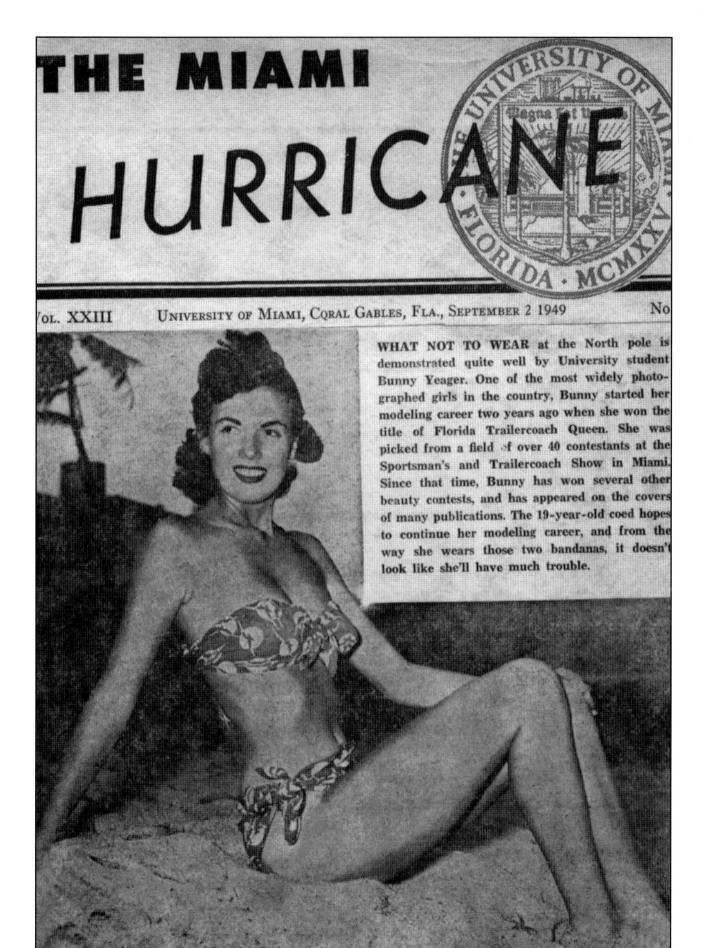

My first "real" bikini suit.

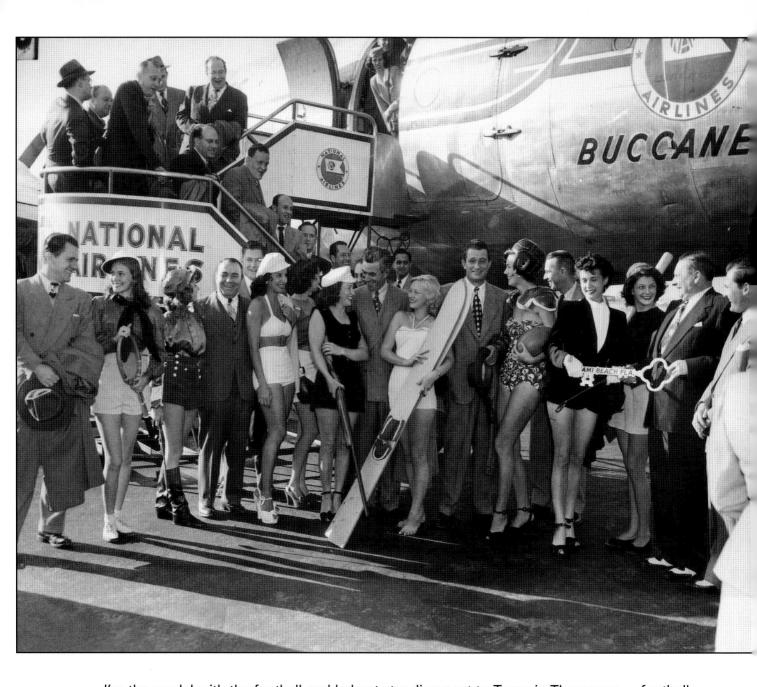

I'm the model with the football and helmet standing next to Tommie Thompson, a football favorite. When my modelling agent called me for this job, I was told to wear a bathing suit. The other girls were dressed to represent various sports. We were sent to greet all these well-known sports figures to get publicity for a charitable affair in Miami Beach. I arrived thinking all the other girls would be in bathing suits too. I felt a little uneasy, especially since I wore my home-made bikini suit instead of a regular bathing suit. I was afraid someone would think it was too revealing and not let me be in the photo. Instead, they put the helmet on my head and handed me the football and gave me a prominent place in the photo. How I hated to put the helmet on and cover my hair, which had just been done at the beauty salon. I thought I looked so ugly, but now I appreciate the shot and what they made me do. This was the kick-off for the Sports Carnival. Joe DiMaggio wasn't on this plane. He was the biggest name for this affair and arrived in another plane privately. Little did I know that day, I would be chosen the winner in the Sports Queen pageant and crowned by Joe. I even had one date with him after the contest before he had to leave. I found him to be rather shy and much like a high school boyfriend would behave on a first date.

Although this all happened in 1949, it represents the first time I wore my bikini in public on an actual modelling job. Before that, it was just being alone with a photographer.

The "Mambo," a Latin dance was invented during this era and "Hula-Hoops" swept the country among adults and children alike. Duck-tails and Pony-tails were seen on a lot of teenagers.

Some of the new words heard were: drive-in movies, miniature golf, suburbia, underpasses, and freeways. Strip shopping centers popped up all over. "White Castle" hamburgers were bought by the bagful. After a date, it was a ritual to go for a hamburger and milkshake at a drive-in where cute girls in short-shorts delivered your order on a tray held high as she skated to your car on roller skates.

In 1950, girls believed in keeping their virginity till marriage. A guy might "play around" with some girls before marriage, but he usually never married them. Yes, the old double-standard prevailed. Women who married were supposed to be homemakers and not have an outside job. The man was the provider and head of the house. Wise women did not take their husbands for granted. Before the time arrived for hubby to come home, she showered, took the pin curls out of her hair, applied make-up and got into a clean starched cotton housedress, which fit her figure like a dress-up dress. Usually she wore a tight wide belt with it. She may not have worn stockings at home, but she never answered the door in big fluffy bedroom slippers. She wore high heels.

When you see ads in magazines from the 1950s showing a woman doing housework, she always looked like that, dressed up like she might be going out. (That was almost real.)

When I went on modeling casting calls in the late 1940s and early 1950s, my agent always insisted I wear a hat and white gloves, in addition to a business suit with hose and high heels. I learned that in modeling school. Today, if someone came to a business office looking for a job dressed with a hat and white gloves, they might think you were eccentric. Times have certainly changed over the years.

When I started shooting bikini photos in the 1950s, I couldn't afford to go to a modeling agency and pay the kind of modeling rates I was used to receiving as a fashion and photographer's model. I had to use "the girl next door," sometimes a friend and sometimes a stranger. I always payed them, but a lot less than a professional model would charge. Usually, these young girls were enthusiastic about posing, but they had no experience and I had to direct them constantly to get them into the pose I wanted. With some, I even had to apply their make-up, because they had never learned how.

I realized from the start of my career as a glamour photographer that magazines would not be so eager to buy one-piece bathing suit shots of an unknown model. I had to do something to make the photos different, more appealing, so I started making bikini suits for my models. I used solid colors like red, yellow, blue, white, and black, as well as interesting patterns, stripes, and polka dots. I didn't use the same suit too many times, and I tried to make a lot of different designs, so my photos would never get boring.

Most girls would wear my bikini suits without hesitation even though they were more revealing than any swimsuits they had ever seen or worn before. Of course, there were some girls who would not be seen in a bikini suit, so I had to photograph them in other original costumes.

Most girls liked wearing my bikini suits, because they were so ahead of their time. Even today, I see copies of my 1950s bikini suits sold in stores, mass-produced by big clothing manufacturers.

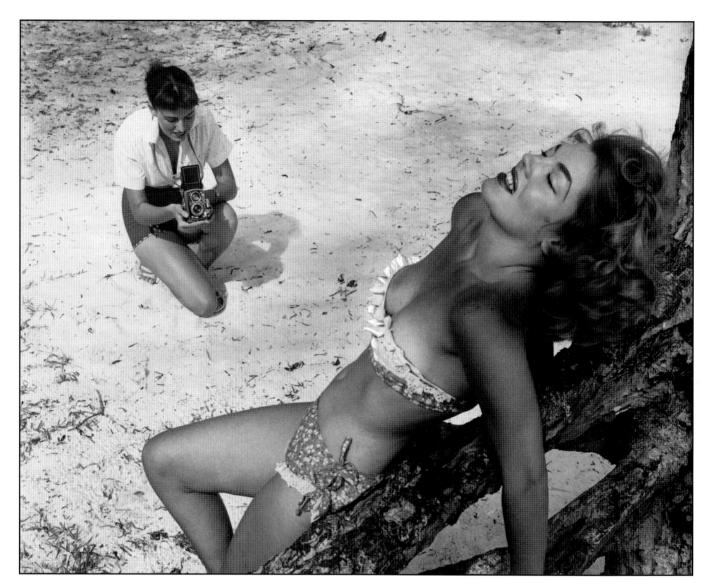

Bunny focuses on Maria Stinger while photographer Allan Gould shoots the whole scene for a pictorial about Bunny

One reason for my success as a glamour photographer was that I was working in the 1950s when new men's magazines were coming out regularly. Some didn't last long, but others moved in to take their place. Almost all were potential markets for the glamour photographer like myself. Unfortunately, today, though there are more men's magazines than ever, there are few magazines where a photographer can regularly sell bikini photos, even though bikinis are briefer than when I sewed them for my models.

This book is not so much about my photography as it is about the girls who are wearing the bikinis. A daring thing to do in the 1950s!!

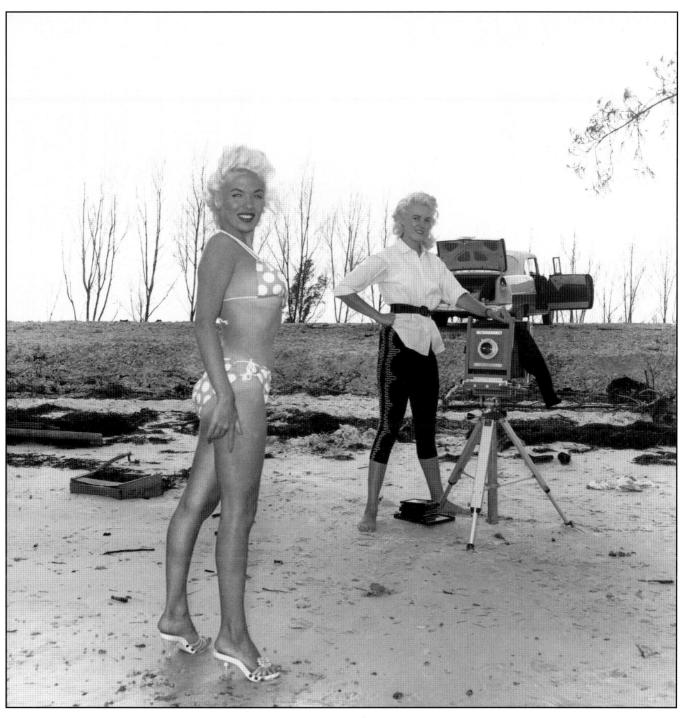

Bunny Yeager at work with model Lori Shea at Naples Beach on the west coast of Florida.

Maria Stinger

Diane Webber

Lori Shea

Bettie Page

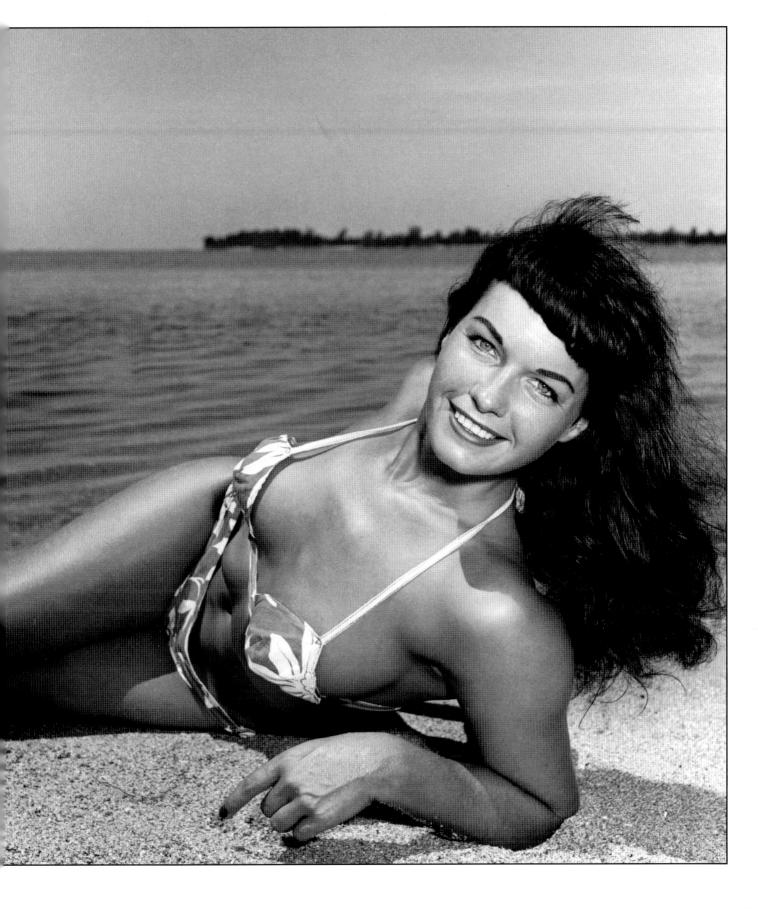

Lisa Winters

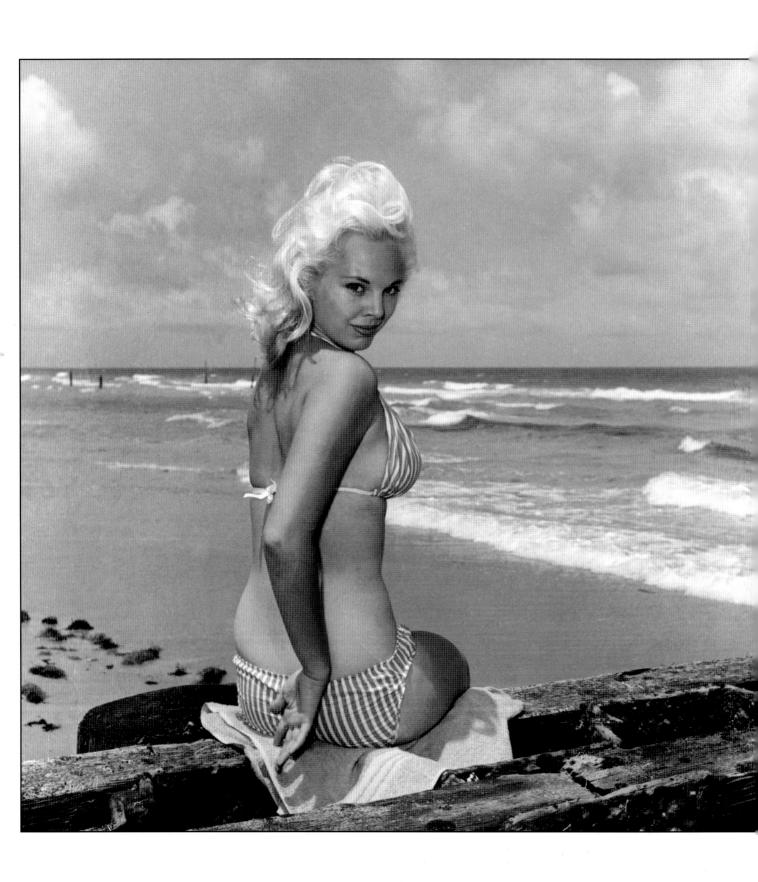

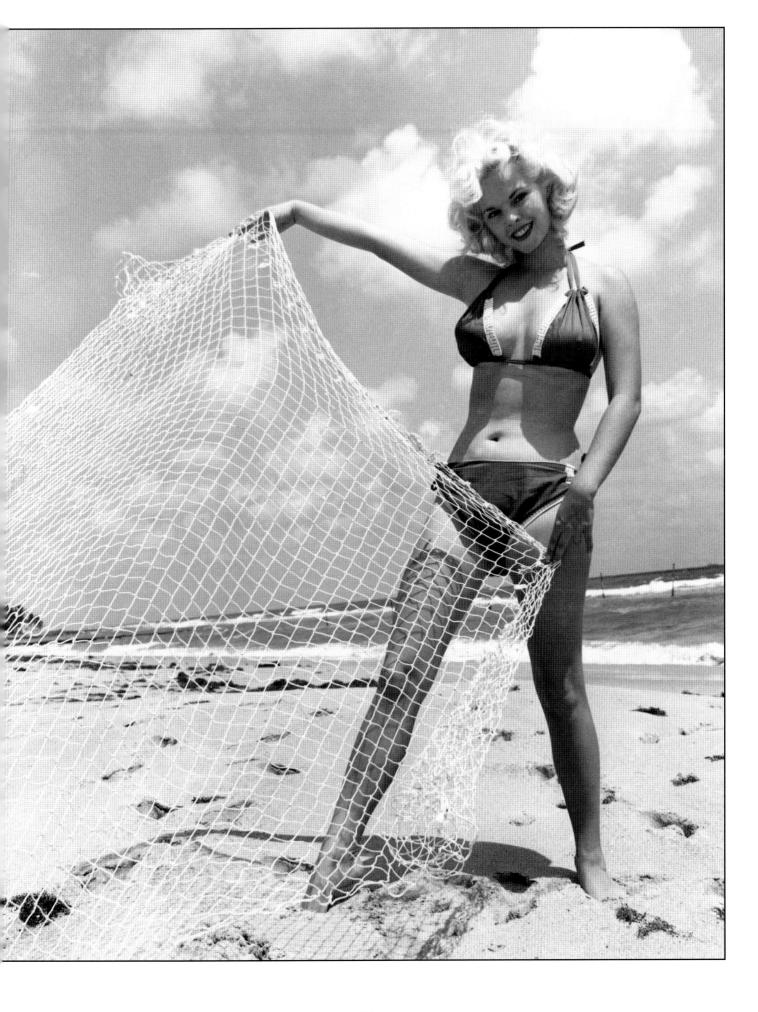

Joyce Nizzari

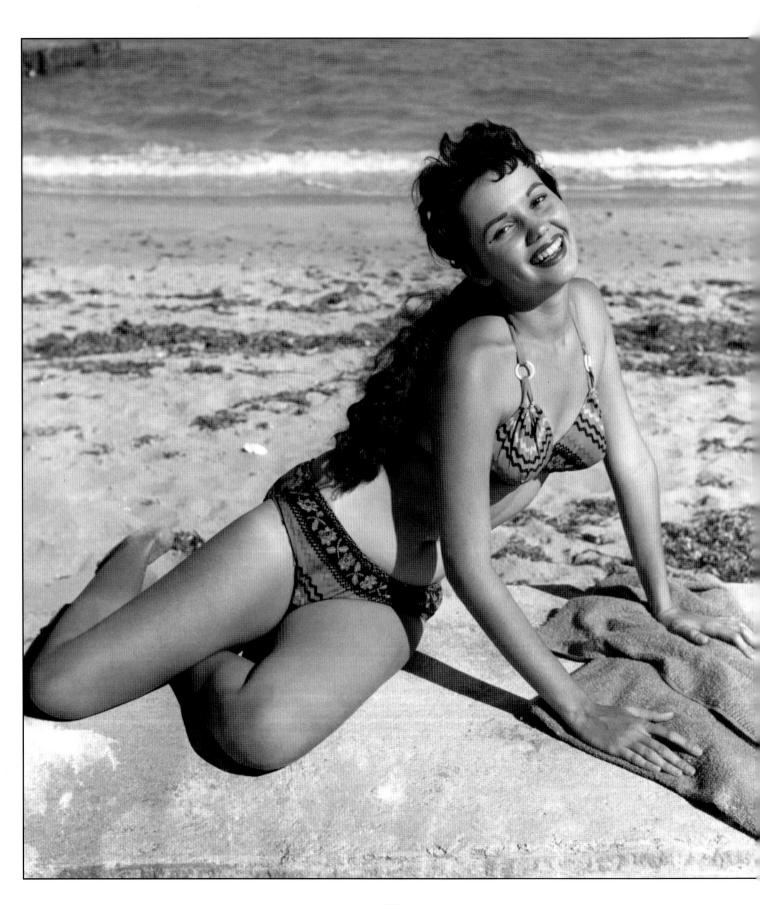

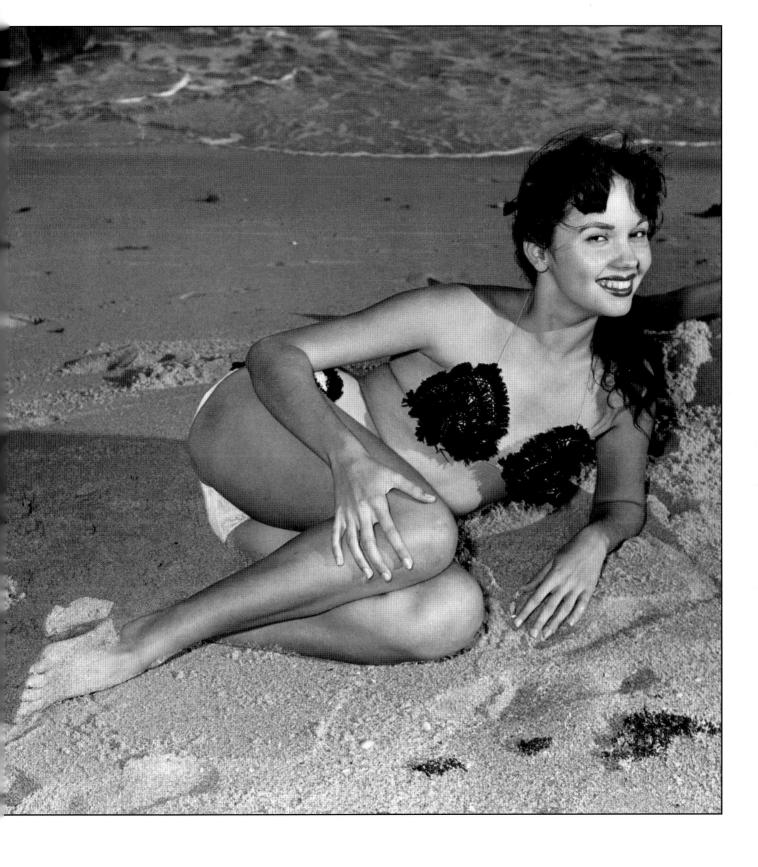

Carolyn Kelly

Eleanor Lucky

Denise Lamont

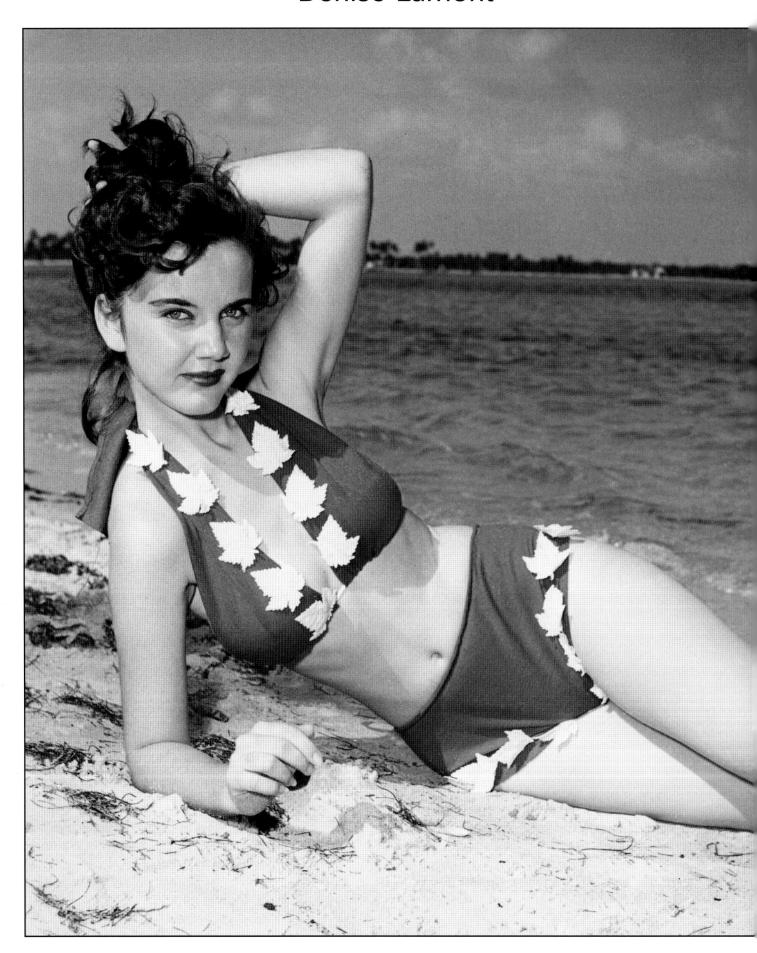

Marcella Patrick

Mara Lindsey

Audi Ragona

Sue James

Terry Shaw

Chris Mara

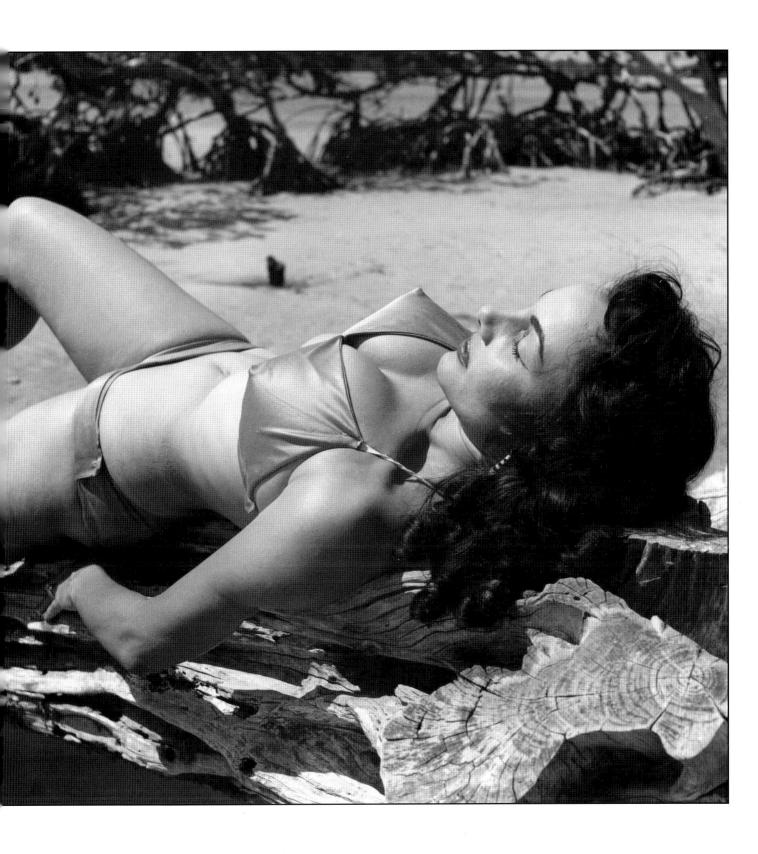

Sharon Knight

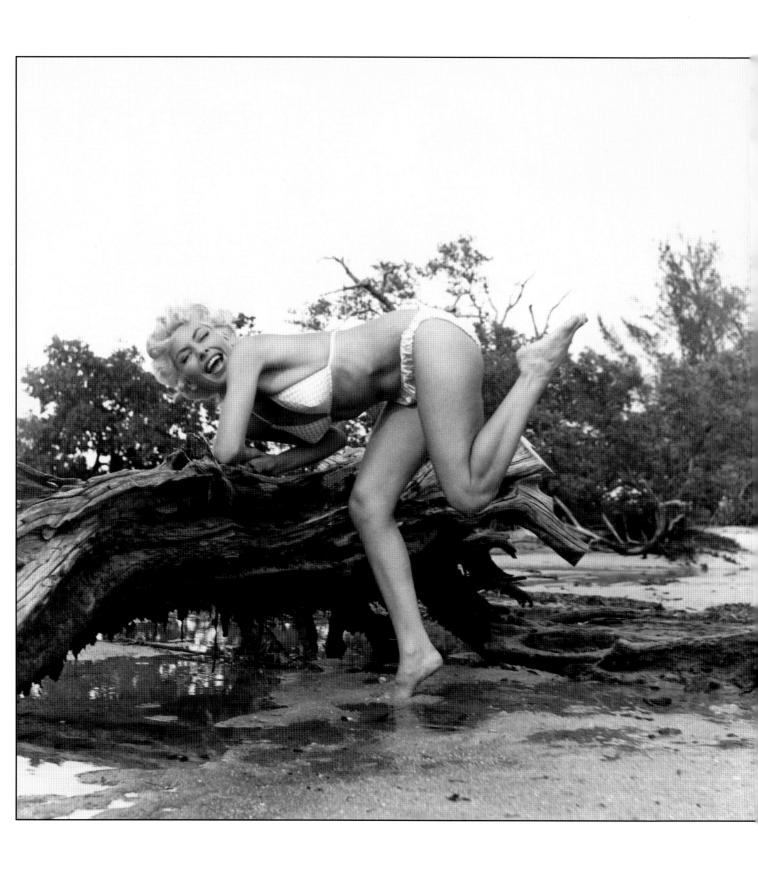

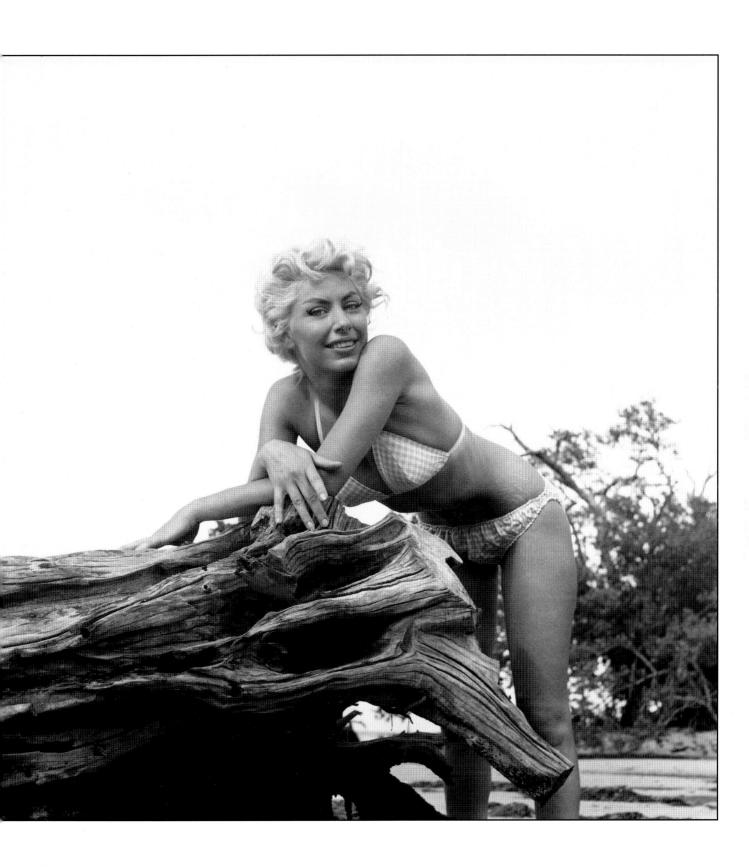

Lana Bashama

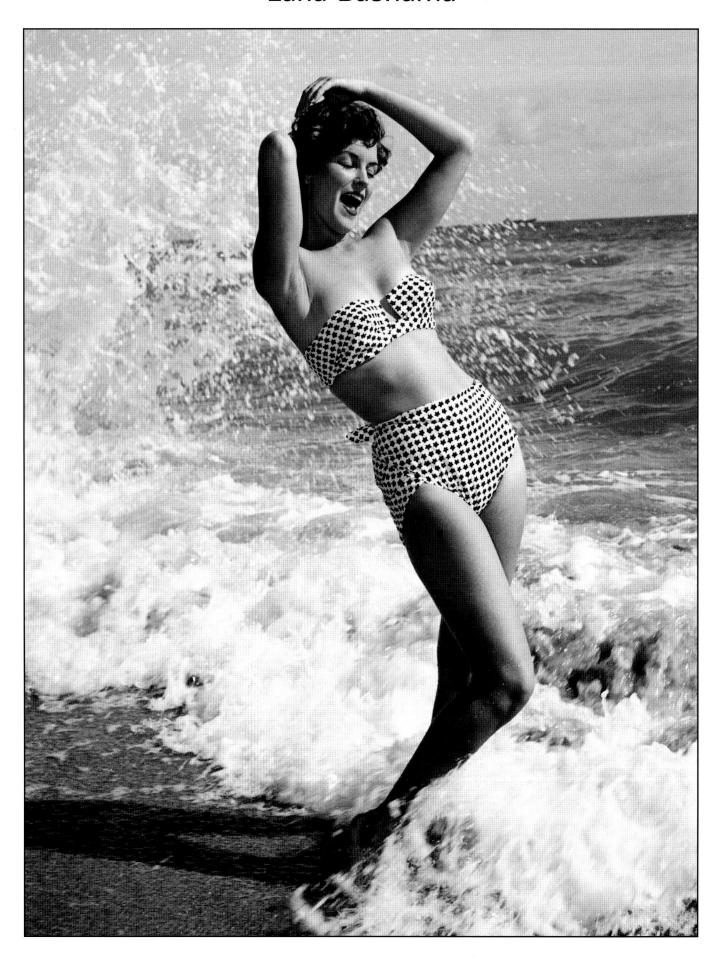

Debbie Norris

Carol Jean Lauritzen

Myrna Weber

Lynn Brooks

Gladys Rogers

Dolly Doyle

Kathleen Stanley

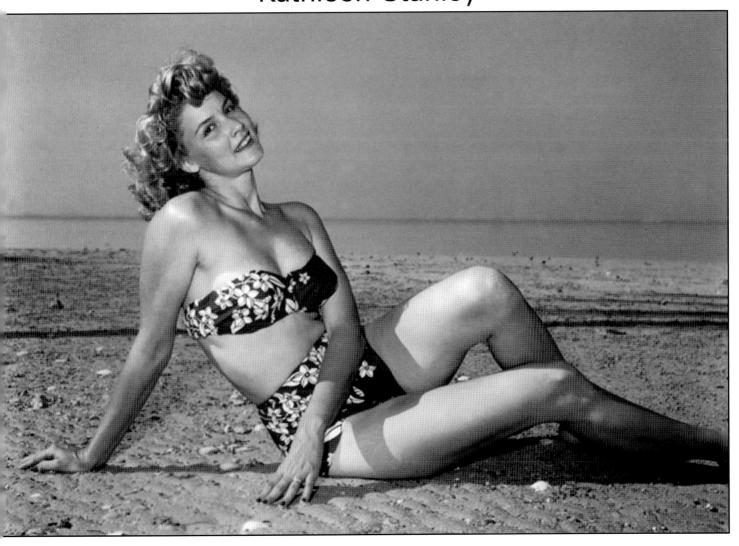

Lillian Bell

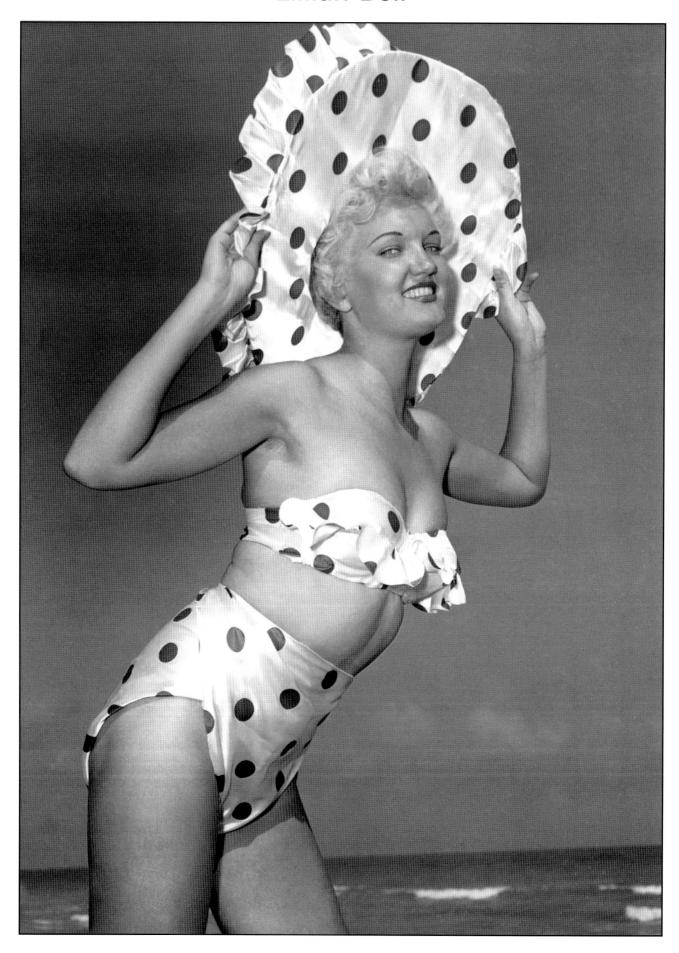

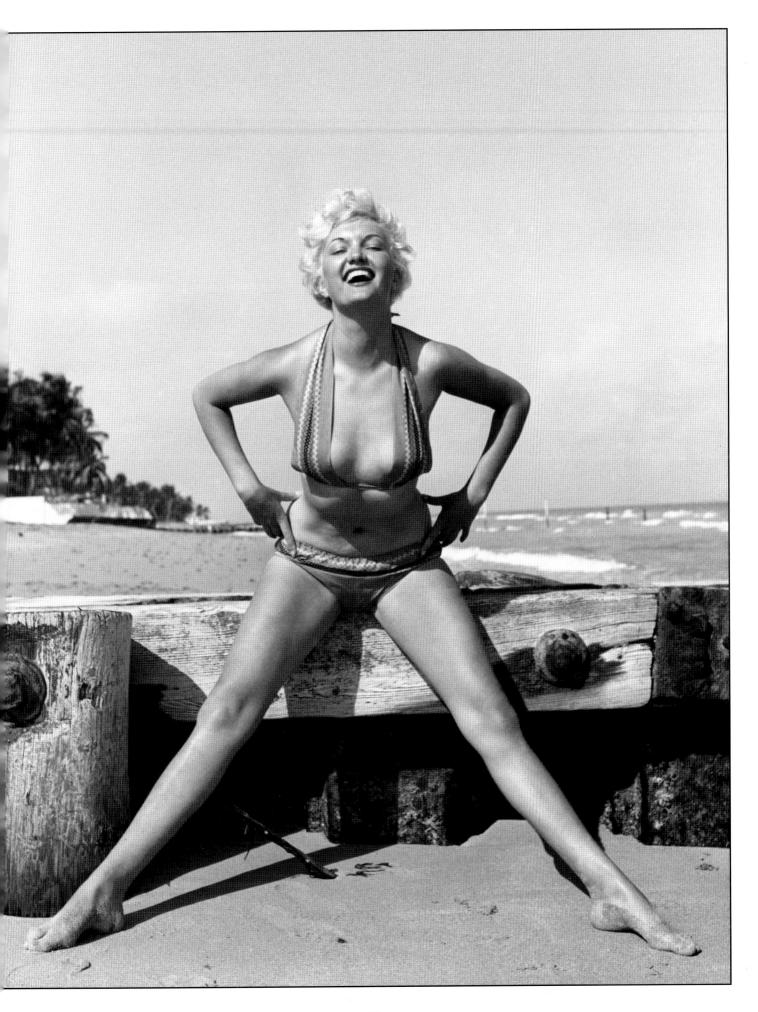

Carol Blake

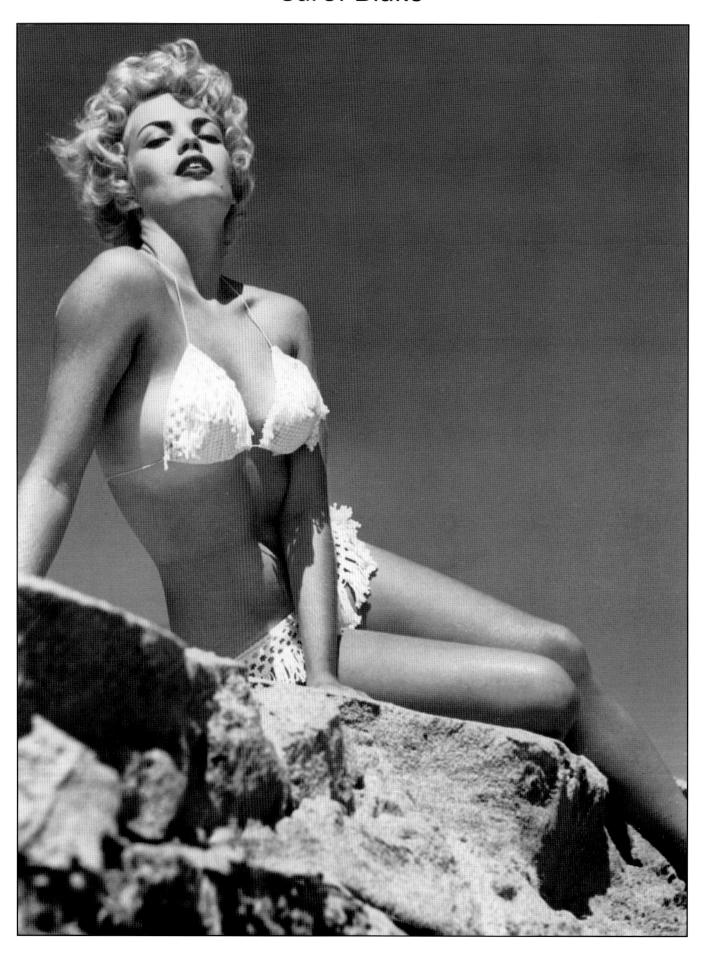

La Raine Meeres

Marcia Valibus

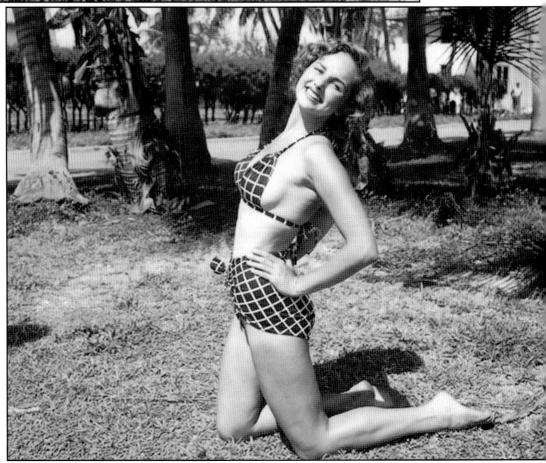

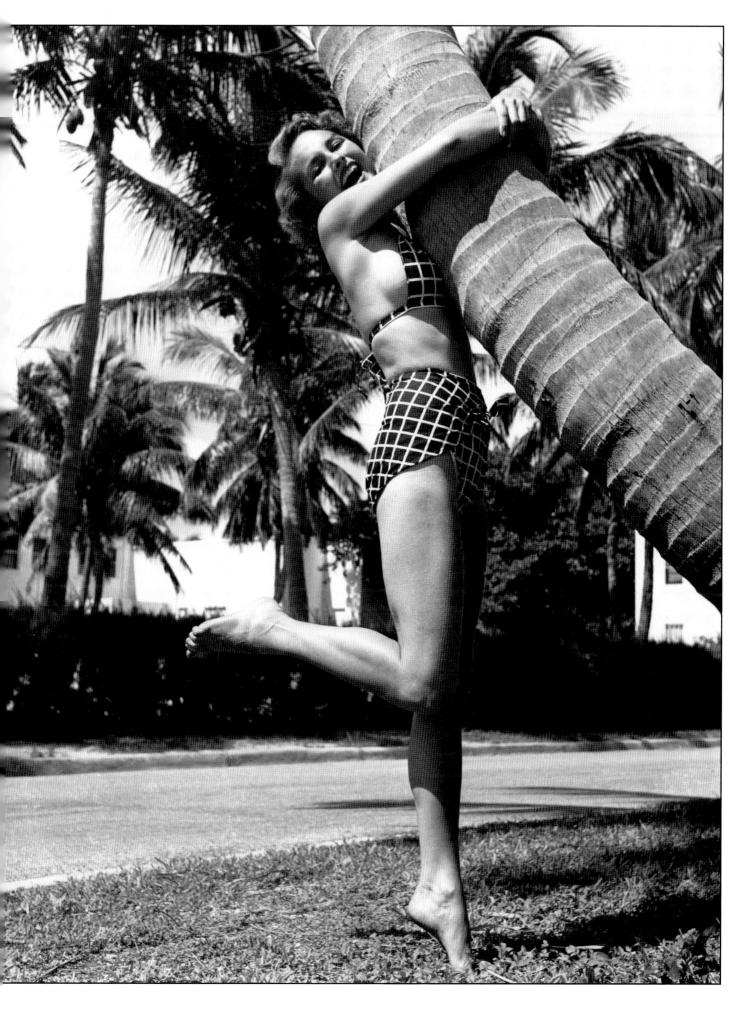

Dominique Chappelle

Patti Patelle

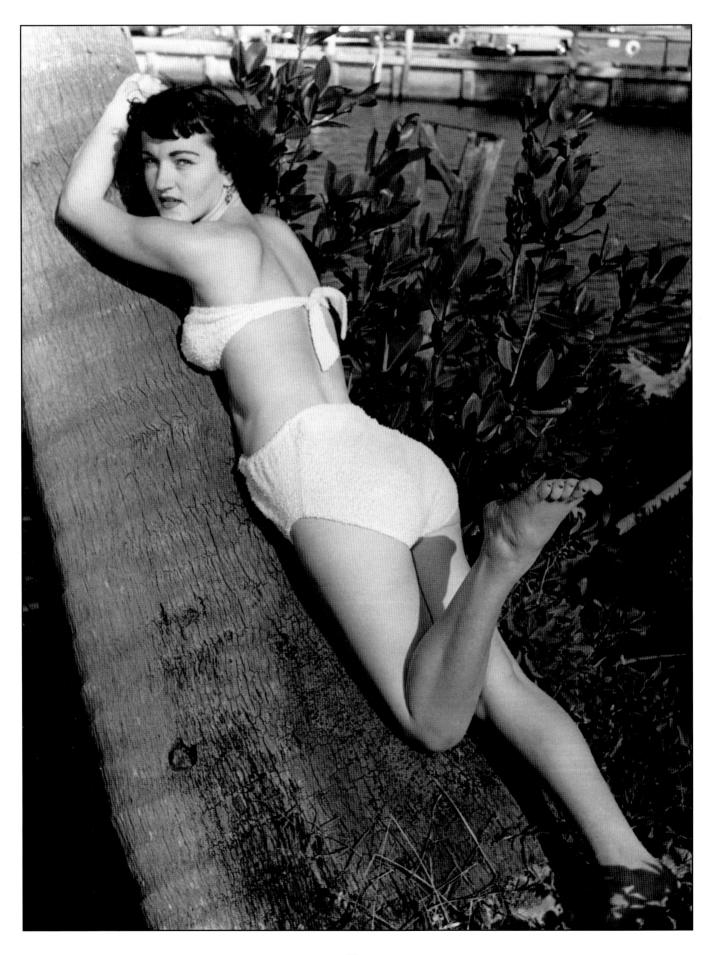

Pat Stanford

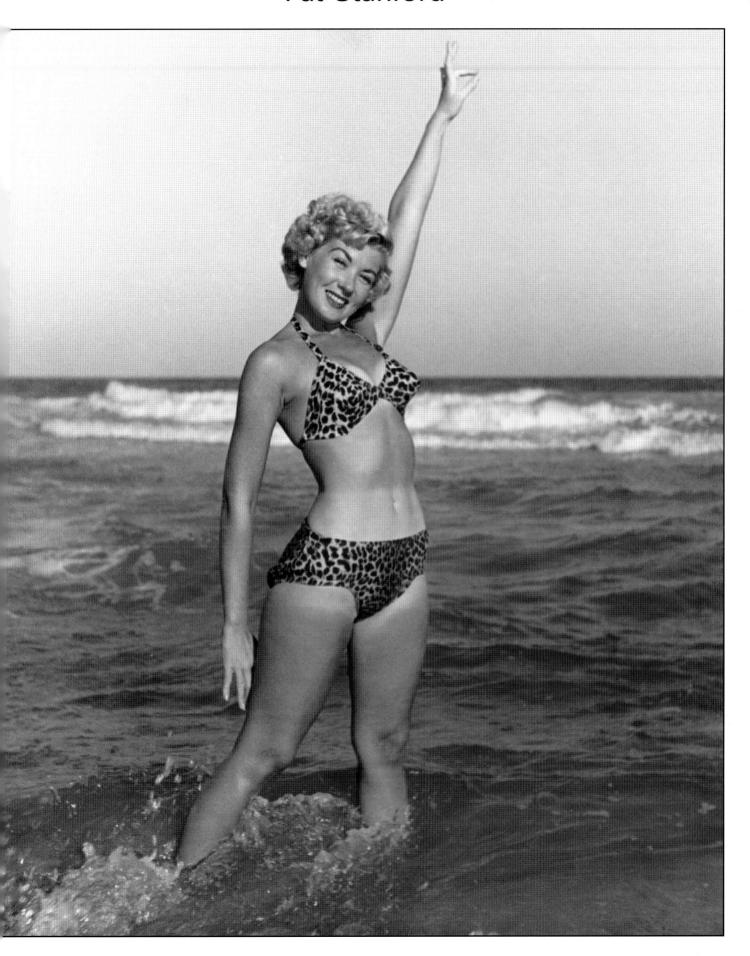

Sandy Fulton

Jackie Walker

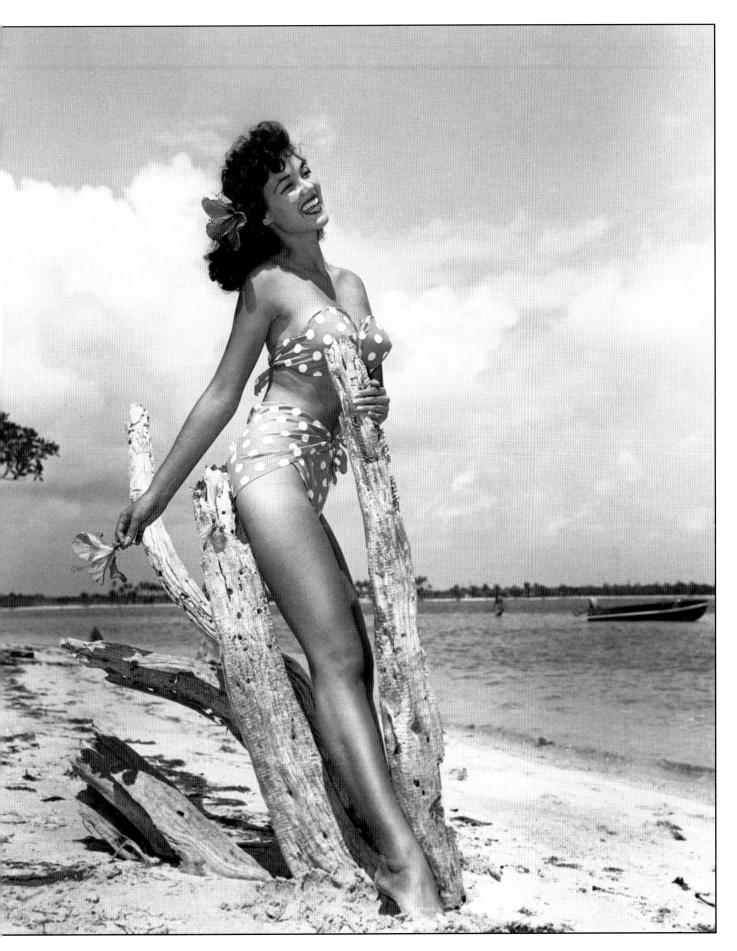

Ginger Meadows

Virginia Remo

Julia Saxon

Nanci White

Carolyn Lee

Yvonne Fredricks

Bonnie Carroll

Julie Padilla

Jennie Lee

Maritza Antoinette

Pat Cooper

Joan Rawlings

Alta Whipple

Carol Britt

Jane Millar

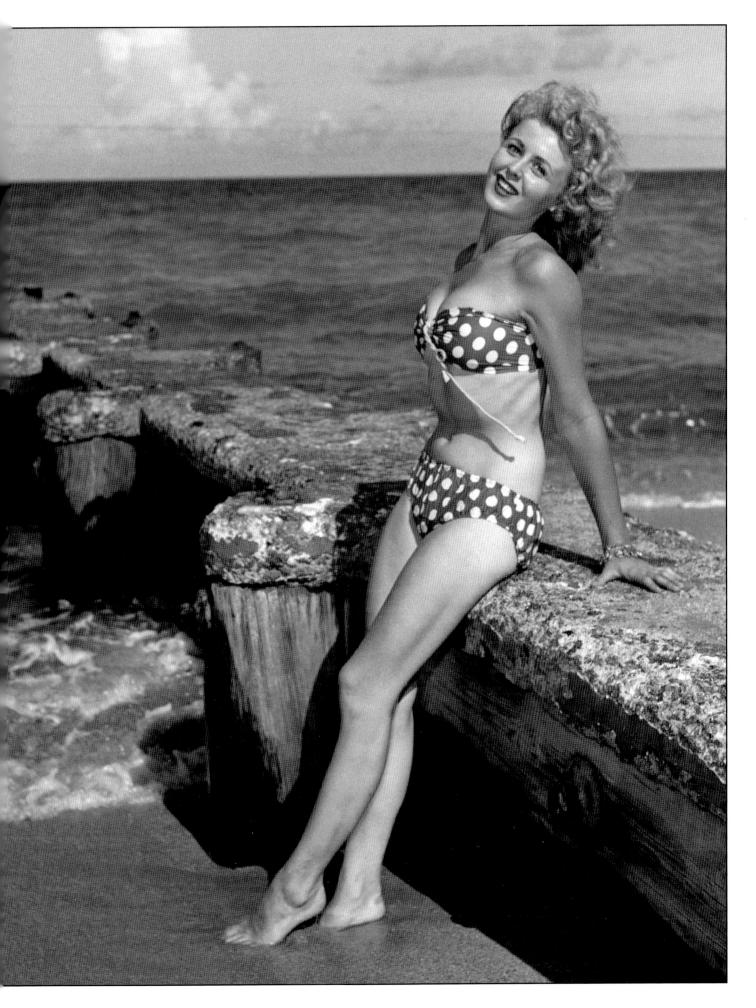

Mickie Marlo

Irene Twinam

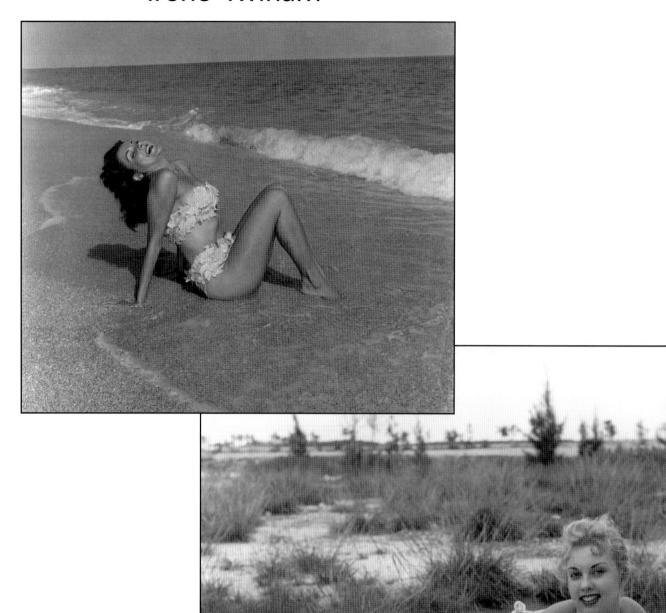

Janet Johnson

Una Diehl

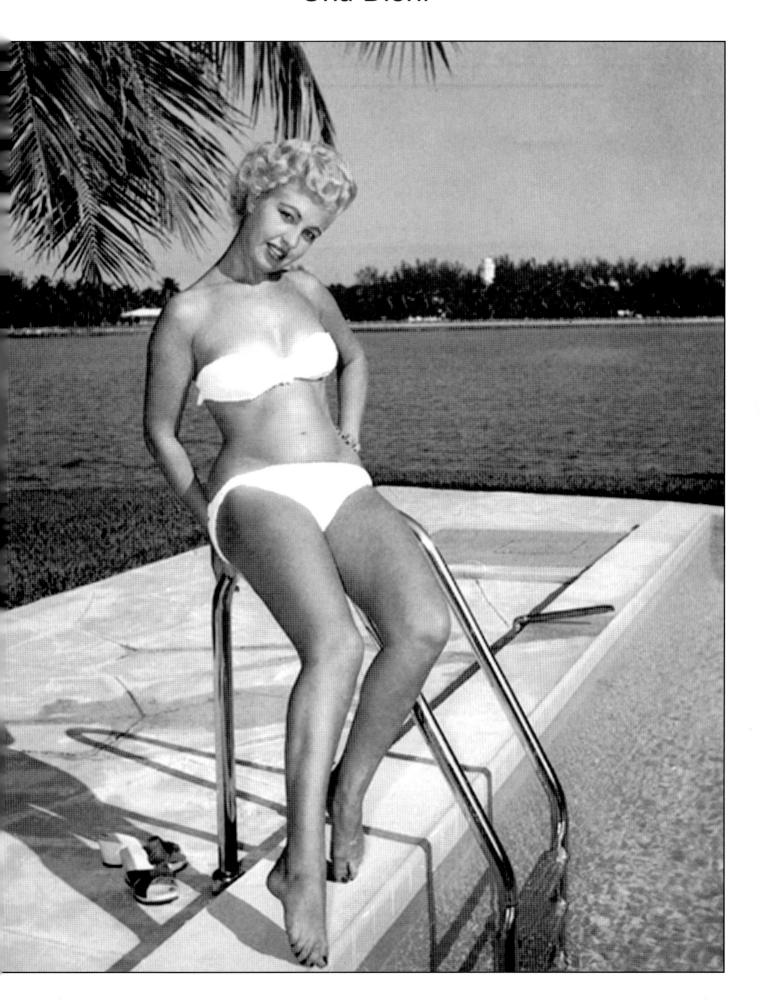

Dottie Sykes

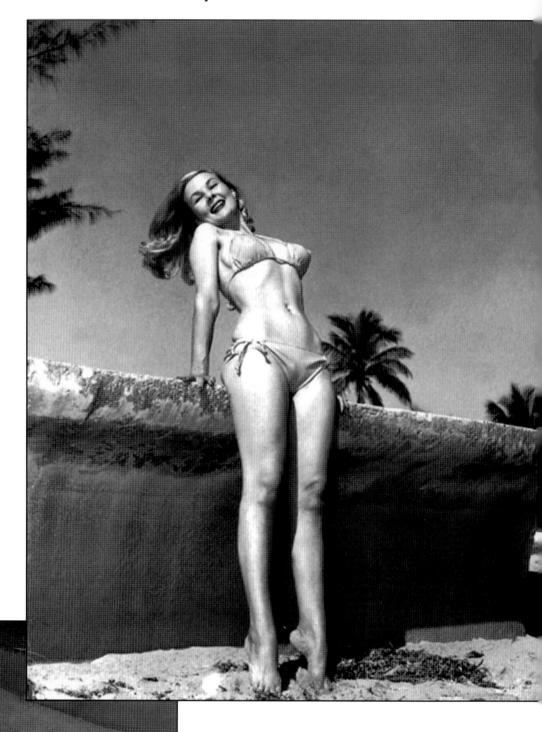

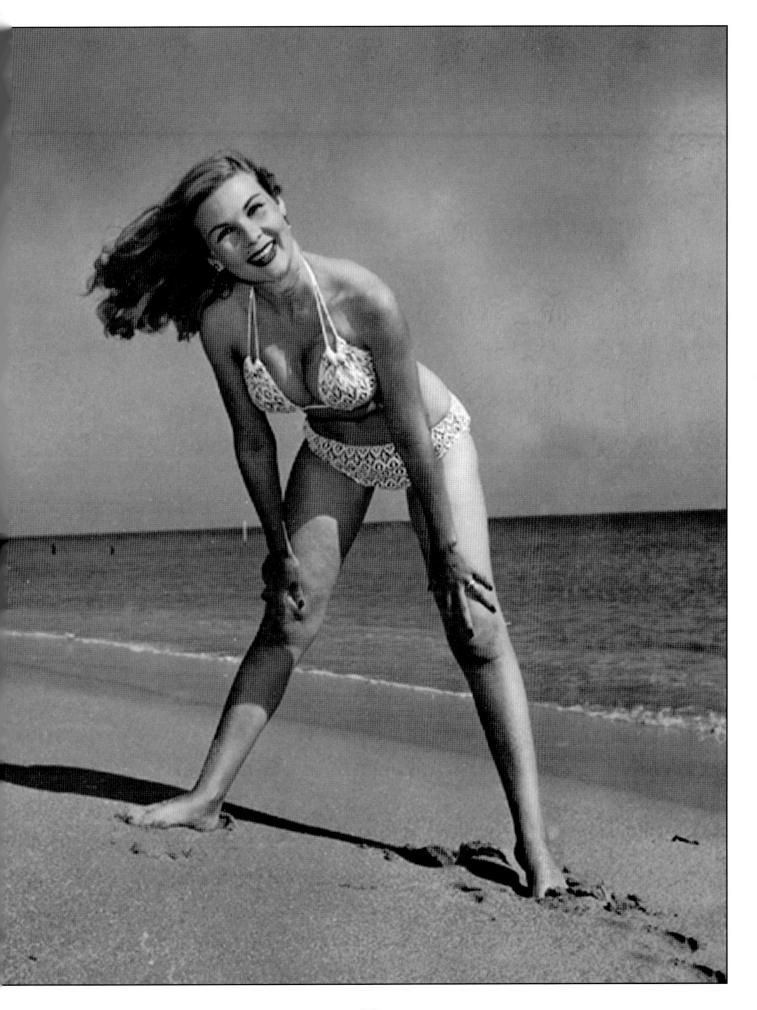

Laurie Scott

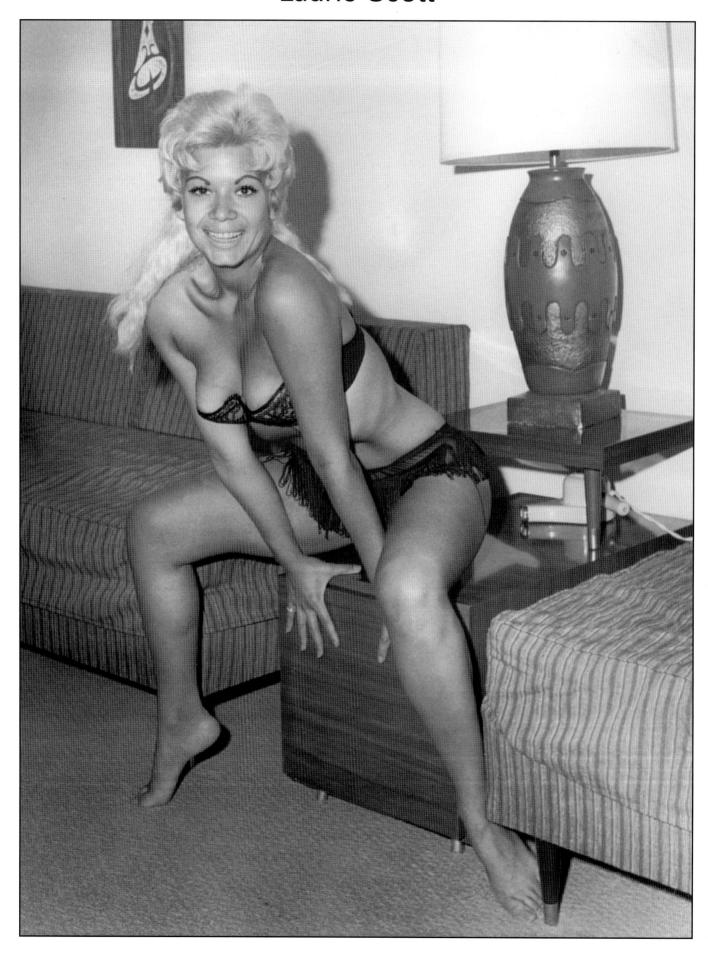

Nadine Ducas

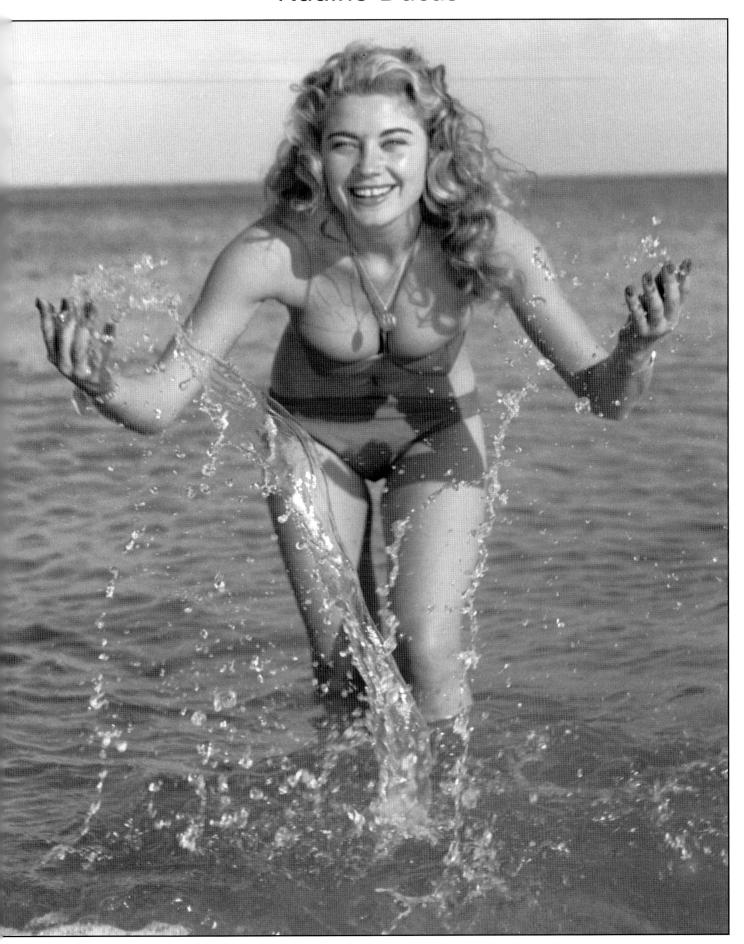

Patti Simmons

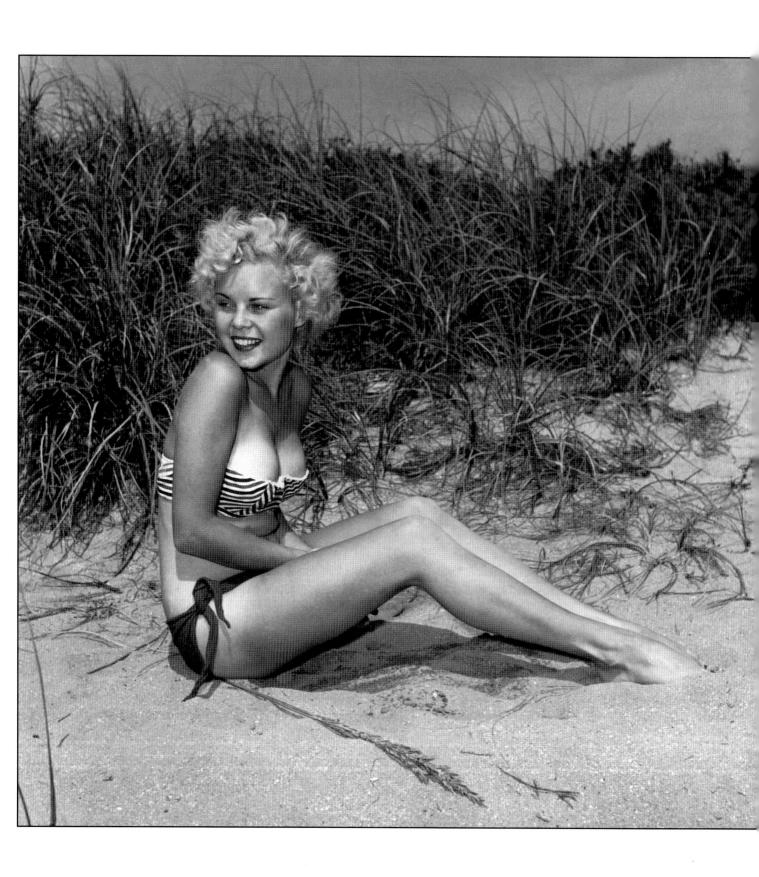

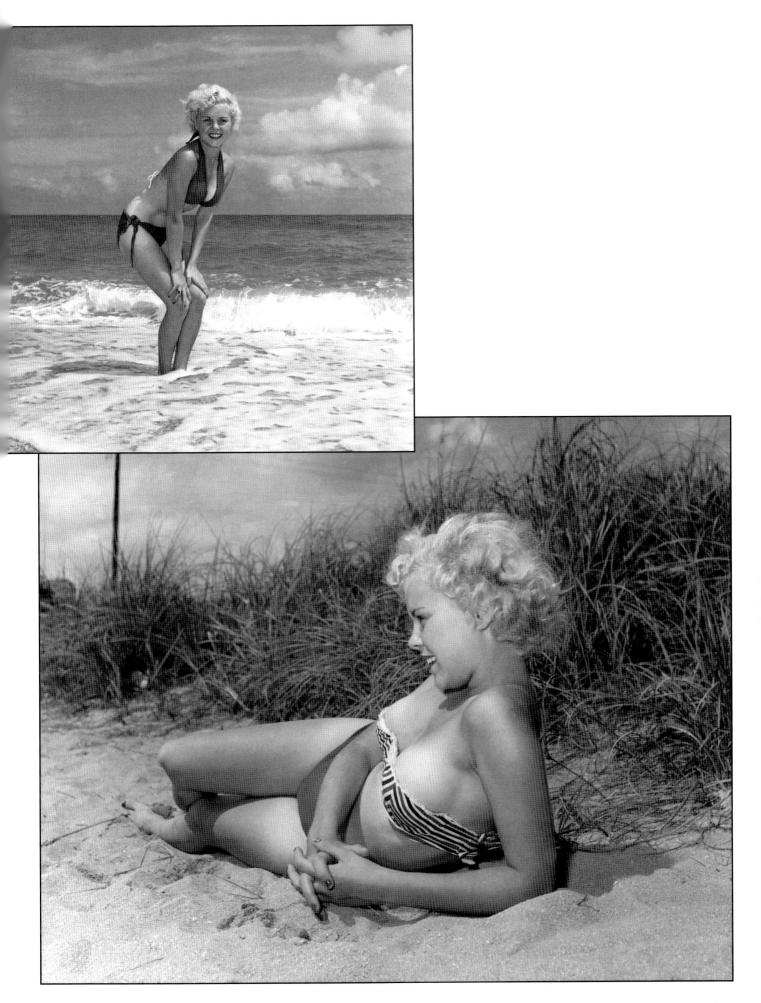

Charlene Mathies

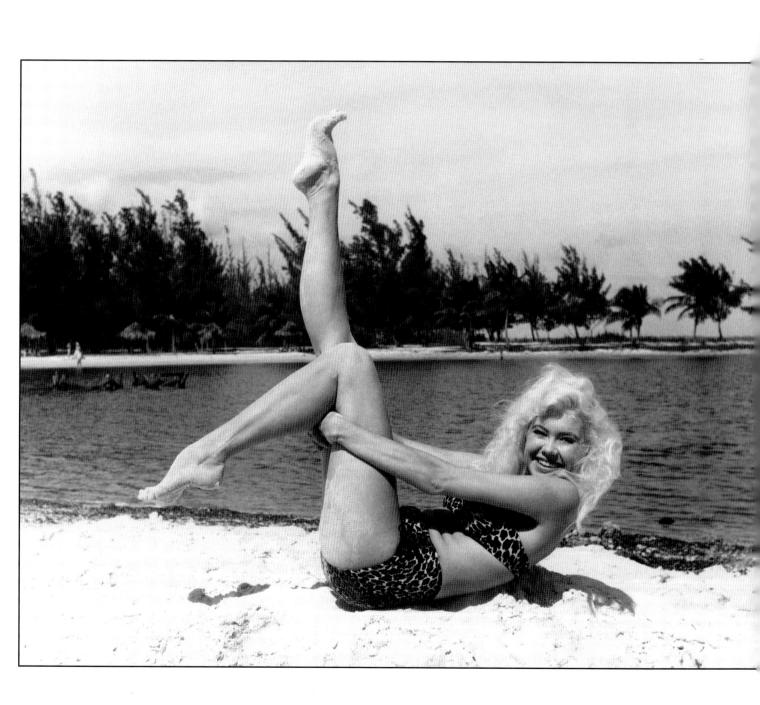

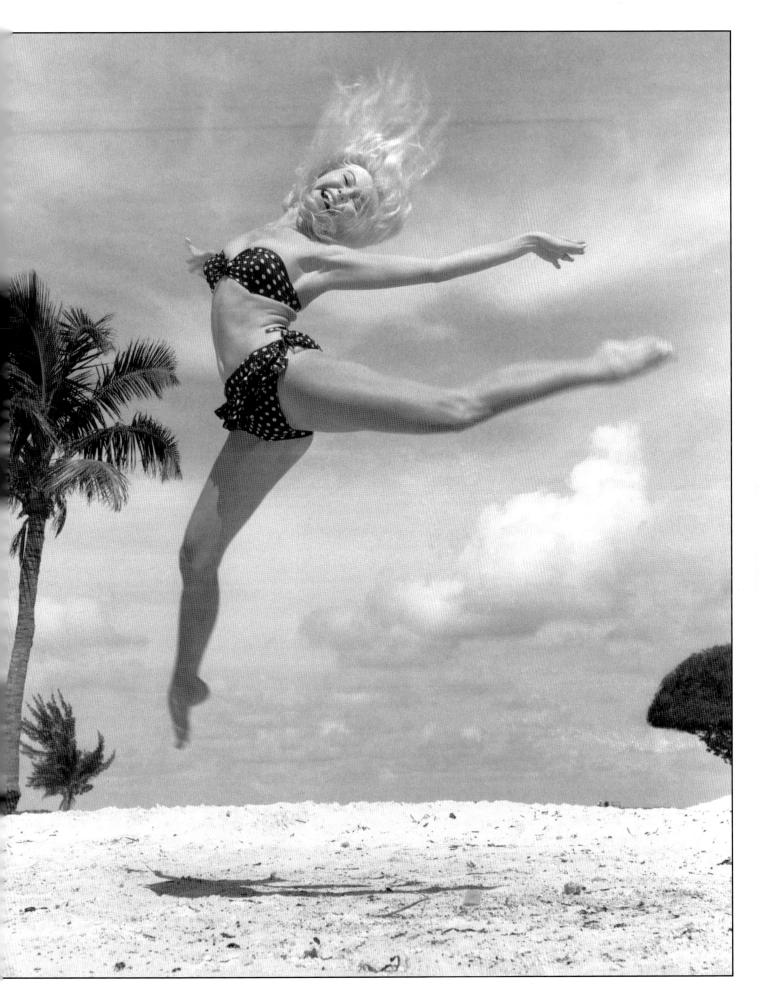

Linda Vargas

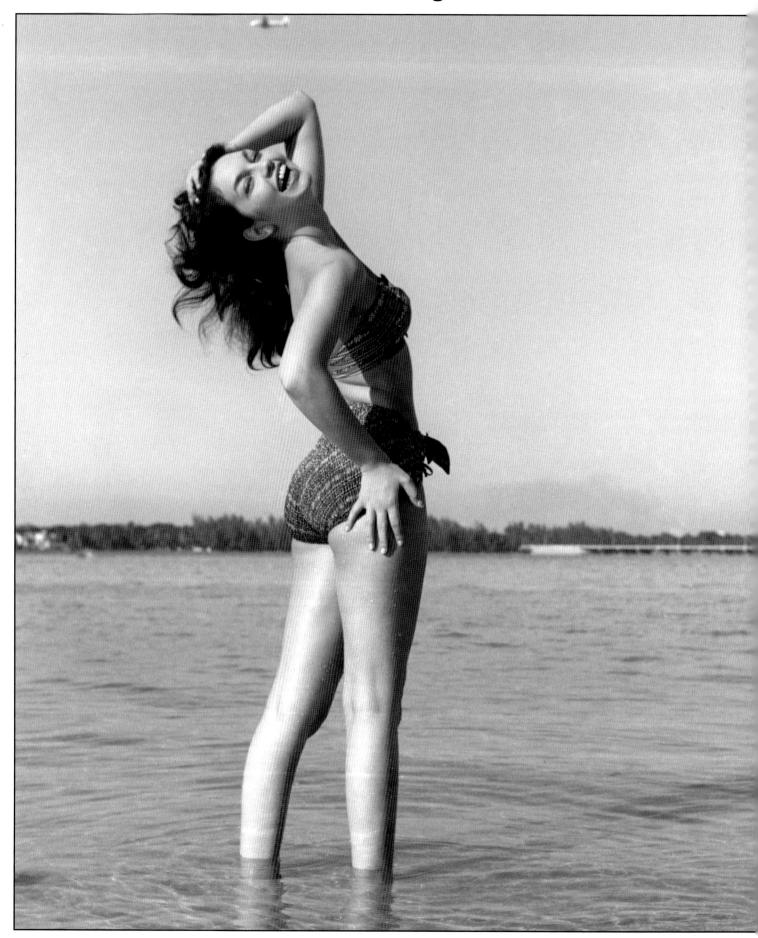

Sally Larimer

Camille Stewart

Gigi Reynolds

Phyllis Ursin

Mary Tilghman

Joanne Geary

Tina Tiffany

Carol Singleton

Marcella Hansen

Nancy Kelly

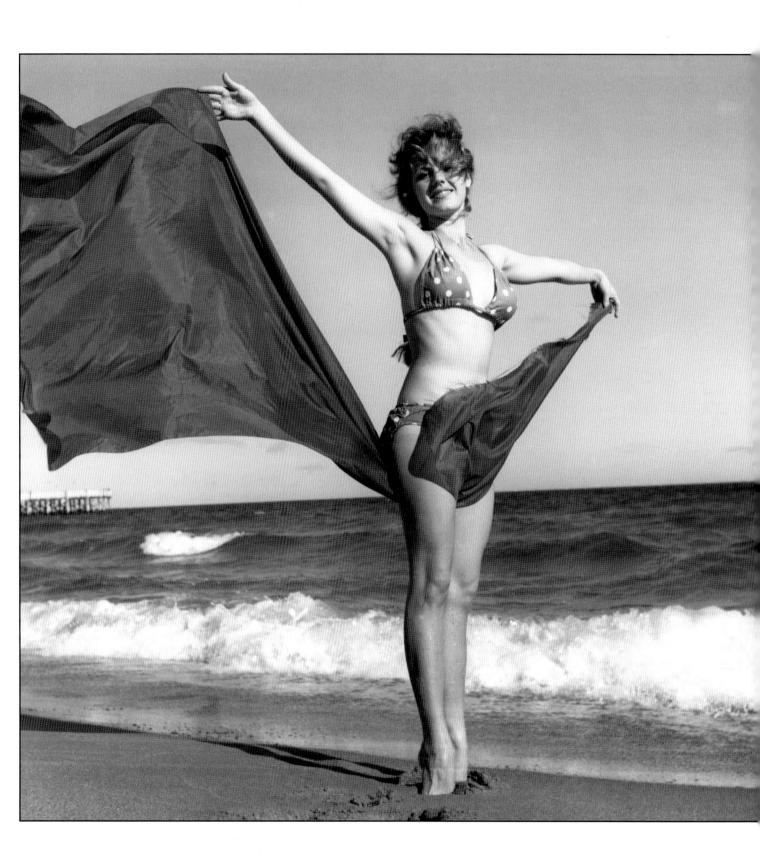

Ruth Shepard

Paula Casey

Kevin Cornell

Marlayna Scott

Rebel Rawlings

Suzanne Harting

Cindy Lee

Maryann Harrison

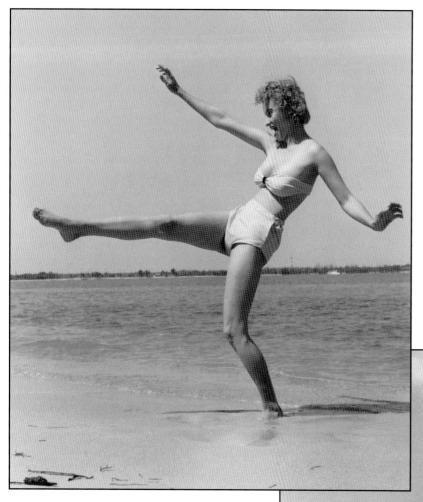

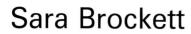

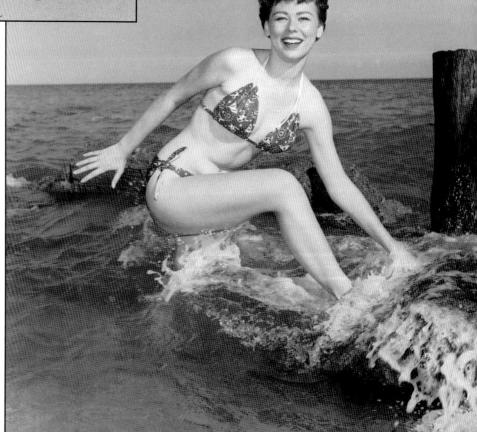

Dawn Reddick

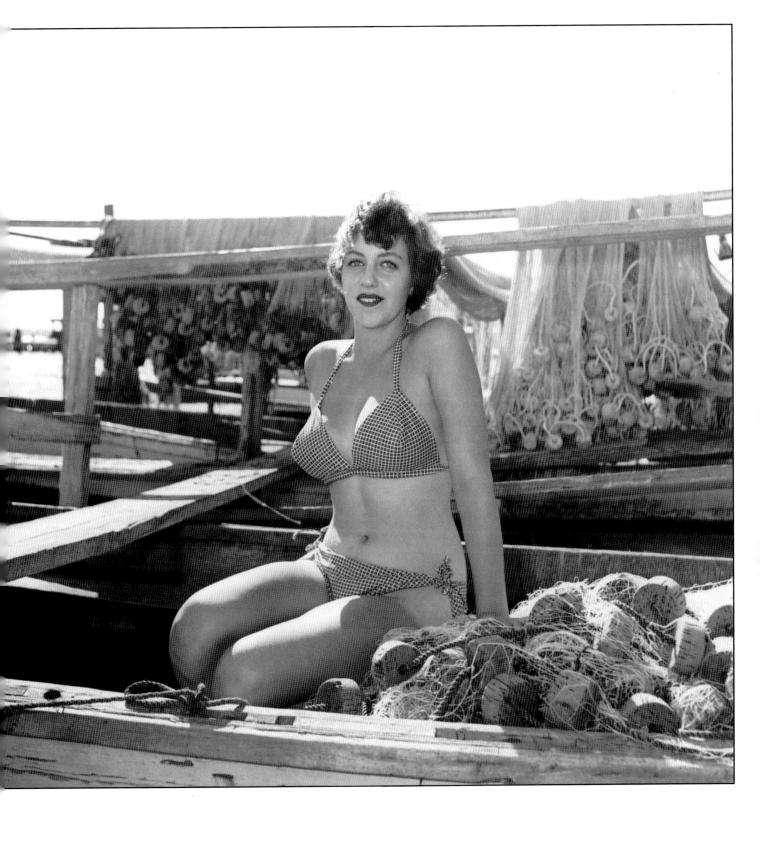

Elaine Deming

Kelly Evans

Index

Antoinette, Maritza, 84, 85 Bashama, Lana, 48 Bell, Lillian, 58, 59 Blake, Carol, 60, 61 Britt, Carol, 13, 92, 93 Brockett, Sara, 124 Brooks, Lynn, 54 Cornell, Kevin, 120 Carroll, Bonnie, 78, 79 Casey, Paula, 120 Chappelle, Domingue, 66, 67 Cooper, Pat, 86, 87 Deming, Elaine, 126 Diehl, Una, 99 Doyle, Dolly, 56 Ducas, Nadine, 103 Evans, Kelly, 127 Fredricks, Yvonne, 77 Fulton, Sandy, 70 Geary, Joanne, 114 Hansen, Marcella, 117 Harrison, Maryann, 124 Harting, Suzanne, 122 James, Sue, 41 Johnson, Janet, 98 Kelly, Carolyn, 34, 35 Kelly, Nancy,- 118 Knight, Sharon, 46, 47 Lamont, Denise, 38 Larimer, Sally, 110 Lauritzen, Carol Jean, 50, 51 Lee, Carolyn, 76 Lee, Cindy, 123 Lee, Jennie, 82, 83 Lindsey, Mara, 40 Lucky, Eleanor, 36, 37 Mara, Chris, 44, 45 Marlo, Mickie, 96, 97 Mathies, Charlene, 106, 107 Meadows, Ginger, 72 Meeres, La Raine, 62, 63

Millar, Jane, 94, 95 Nizzari, Joyce, 32, 33 Norris, Debbie, 49 Padilla, Julie, 80, 81 Page, Bettie, 28, 29 Patelle, Patti 68 Patrick, Marcella, 39 Ragona, Audi, 41 Rawlings, Joan, 88, 89 Rawlings, Rebel, 121 Reddick, Dawn, 125 Remo, Virginia, 73 Reynolds, Gigi, 111 Rogers, Gladys, 55 Saxon, Julia, 73 Scott, Laurie, 102 Scott, Marlayna, 121 Shaw, Terry, 42, 43 Shea, Lori, 26, 27 Shepard, Ruth, 119 Simmons, Patti, 104, 105 Singleton, Carol, 1, 116 Sloan, Eva, 57 Stanford, Pat, 69 Stanley, Kathleen, 13, 57 Stewart, Camille, 111 Stinger, Maria, 22, 23 Sykes, Dottie, 100, 101 Tiffany, Tina, 115 Tilghman, Mary, 112, 113 Twinam, Irene, 98 Ursin, Phyllis, 111 Valibus, Marcia, 64, 65 Vargas, Linda, 108, 109 Walker, Jackie, 4, 71 Webber, Diane, 24, 25 Weber, Myrna, 52, 53 Whipple, Alta, 90, 91 White, Nanci, 13, 74, 75 Winters, Lisa, 30, 31

CW00765909

Suste Brooks

The LAND and the PEOPLE

Published in Great Britain in 2018 by Wayland

Copyright © Wayland, 2016

All rights reserved

Editor: Nicola Edwards Design: Smart Design Studio Map artwork by Stefan Chabluk

ISBN: 978 0 7502 9818 6 10 9 8 7 6 5 4 3 2 1

MIX
Paper from
responsible sources
FSC® C104740

Wayland, an imprint of Hachette Children's Group Part of Hodder and Stoughton Carmelite House 50 Victoria Embankment London EC4Y ODZ

An Hachette UK Company www.hachette.co.uk www.hachettechildrens.co.uk

Printed in China

1952 JUNIOR NON-FICT

Picture acknowledgements: All images and graphic elements courtesy of Shutterstock except pp 9b, 1lt and b, 18t, 23t and b, 27m and b, 28b,40t, 42t and 44b Corbis; pp 20b, 2lt and 22br Wikimedia Commons.

Every attempt has been made to clear copyright. Should there be any inadvertent omission, please apply to the publisher for rectification.

The website addresses (URLs) included in this book were valid at the time of going to press. However, it is possible that contents or addresses may have changed since the publication of this book. No responsibility for any such changes can be accepted by either the author or the Publisher.

CONTENTS

Japan on the Map	4.	Get the Look
The People's Story	6	Work and Leisure
Island Nation	8	Dates to Celebrate
Ring of Fire	10	Tastes of Japan
Skysoraper Cities	12	Born to Perform
High-Tech Travel	14	Creative Culture
Life on the Land	16	Japan Today
Nature's Resources	18	Quiz
Wild Japan	20	Glossary
Amazing Innovations	22	Index
Traditional Customs	24	焼焼の店 一番 一番 一番 一番 一番 一番 日本 一番 日本 一番 日本 一番 日本 一番 日本 一番 日本
All Sorts of Sports	26	4F Dug
Martial Arts	28	By Duck States

32

34.

36

38

4.()

42

4.4.

46

4.7

4.8

JAPAN ON THE MAP

CHINA

RUSSIA

Dicture a country surrounded by sea, where volcanoes erupt and the world's fastest trains whizz by. That's Japan! This fascinating place is like a world of its own, separated from the coast of mainland Asia.

Cultures collide

Japan is home to an amazing combination of Eastern and Western influences. There are Shinto shrines and skyscraper cities, chopsticks, tea ceremonies and robots. This a land where ancient traditions meet futuristic technology and the earthshattering forces of nature.

JAPAN RANKS 62ND IN THE WORLD IN COUNTRY SIZE, BUT 10TH IN SIZE OF POPULATION!

> Sea of Japan

SOUTH KOREA

Japan fact file

Population: 126,919,659 (July 2015 est.

Area (land and sea): 377,915 sq km

Capital city: Tokyo

Highest peak: Mount Fuji (3,776m)

Main language: Japanese

Currency: Japanese Yen (JPY)

Shikoku

Kyushu

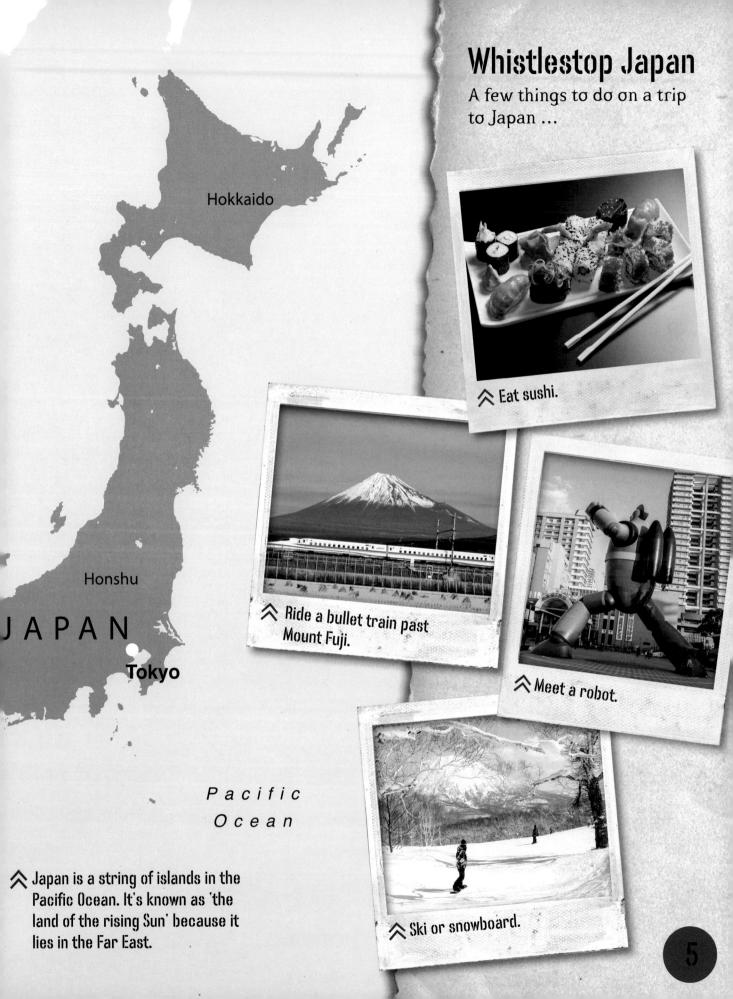

The Jomun culture is named after the cord markings made on its pots.

People have lived in Japan for at least 30,000 years! The first settlers arrived during the last ice age, when land bridges joined Japan to the mainland. As the ice age ended, around 12,000 BCE, the sea rose and separated Japan.

Early Japan

From about 10,000 BCE, a culture called the Jomun culture grew up. Its people made stone tools and survived by fishing, hunting and gathering. The Yayoi took over in about 300 BCE, and by the 500s CE, a powerful clan called the Yamato was in control. Japan became a unified state, led by a series of emperors.

JAPAN STILL HAS AN
EMPEROR, THOUGH HE HOLDS NO
POLITICAL POWER. EMPEROR AKIHITO
(SON OF HIROHITO) BECAME HEAD
OF STATE IN 1989.

Many influences came from China during the Yamato period, including the religion Buddhism. This is Japan's oldest Buddhist temple, Höryū-ji.

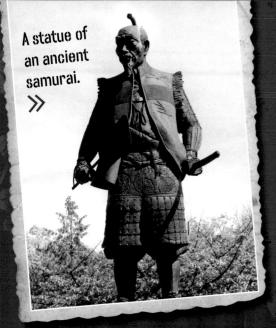

Samurai and shoguns

Alongside its emperors, Japan had a strong military, and in the 1100s warriors called the samural gained power. They were experts in sword fighting, archery and martial arts (see p28-29). A series of shoguns – military chiefs – ruled Japan for about 700 years.

MODERN ERA 1868, the Emperor Meiji won back om the shoguns and began

In 1868, the Emperor Meiji won back control from the shoguns and began to modernise Japan. It soon became the most powerful nation in Asia, fighting wars and claiming territory in China and Russia. The USA tried to intervene in Japanese invasions, and Japan responded with an attack on Pearl Harbour, Hawaii in 1941. In 1945, the USA dropped devastating atomic bombs on the Japanese cities of Hiroshima and Nagasaki. The USA occupied Japan until 1952, after which Japan developed as the peaceful democracy it is today.

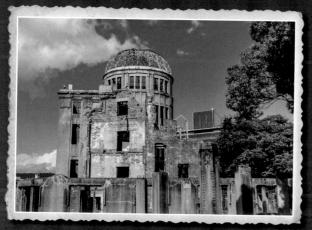

Japan is the only country in history to have suffered a nuclear bomb attack. More than 150,000 people died as a result - this is a memorial to them in Hiroshima.

Famous Japanese

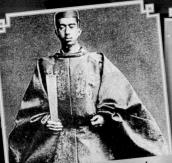

Hirohito - Japan's longestreigning emperor (1926-89), whose rule spanned World War II

Yoko Ono – artist, musician and epeace activist who was married to the Beatle John Lennon

Issey Miyake – modern fashion designer, known for his innovative ways of producing clothes

lchiro Suzuki - professional baseball player and national hero in Japan

ISLAND NATION

You could spend a long time hopping about Japan's islands - there are literally thousands of them, though the majority are tiny and uninhabited. Most people live on the four biggest islands: Honshu, Hokkaido, Kyushu and Shikoku.

Mount Fuji is a popular volcano to climb. There's even a post office at the top so you can send a postcard!

Mountainous land

Japan was formed over millions of years by two plates of Earth's crust pushing together under the sea. This forced up a chain of mountains, which make up most of Japan's landscape. The highest of all is the majestic Mount Fuji, a cone-shaped volcano that last erupted in 1707.

Reflection in a paddy field - a woman plants rice at the foot of Mount Fuji.

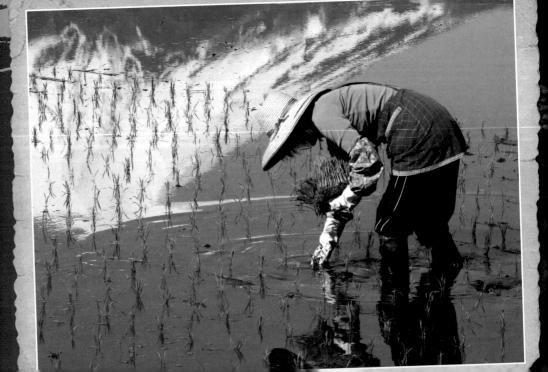

Surrounded by sea on all sides, Japan has a massive 29,751km coastline. Its rivers are short but steep, flowing fast down mountain slopes. There are plunging gorges with dramatic waterfalls tumbling over them. Many lakes have formed up high in the craters of extinct volcanges.

The Tenryu River flows through a national park.

A waterfall tumbles over Takachiho Gorge. ≫

FOCUS ON

VARIED CLIMATE

The islands of Japan trail for over 3,000km, and the climate varies from place to place. In the north the summers are short and winters long and snowy, while in the south it's warmer year-round. Japan is affected by the monsoon, a seasonal wind that brings heavy rains from June to October. The country experiences lots of typhoons (tropical storms) at this time of year, often causing dangerous floods and landslides. In 2015, more than 100,000 people were forced to flee their homes as Typhoon Etau (right) brought torrential downpours and rivers burst their banks.

RING OF FIRE

Japan sits on one of the least stable parts of Earth's crust - a region around the Pacific Ocean, known as the Ring of Fire. This is a place where earthquakes and volcanoes regularly rattle the landscape.

The volcano Sakurajima erupts March 30, 2010 in Kagoshima City, Japan. ≫

Violent volcanoes

Japan has about 110 active volcanoes – in other words, ones that have erupted in the last 10,000 years. Many are very close to populated areas, so scientists monitor them all the time and evacuate people if they predict an eruption.

Children at a school in Toyko take part in a disaster drill called 'Shakeout Tokyo'.

FOCUS ON DISASTER 2011

In 2011, a gigantic earthquake struck under the sea near Japan. It was the strongest the country had seen, and the fifth strongest in the world, since records began. The quake threw up a tsunami that bulldozed the coastline and charged up to 10km inland. It killed nearly 16,000 people, left hundreds of thousands homeless and caused a meltdown at the Fukushima Daiichi nuclear power plant. Dangerous radiation leaked out and affected a vast area. The disaster cost Japan's economy over US\$300 billion, and recovery is still underway.

Shaking quakes

Up to 1,500 earthquakes rock Japan each year, though most are too small to cause damage. When large quakes strike under the sea, they can shake up giant waves called tsunamis. Japan excels in earthquake-resistant buildings, evacuation drills and tsunami defences. Even so, major disasters can happen (see below).

ABOUT A FIFTH
OF THE WORLD'S
EARTHQUAKES HAPPEN
IN JAPAN.

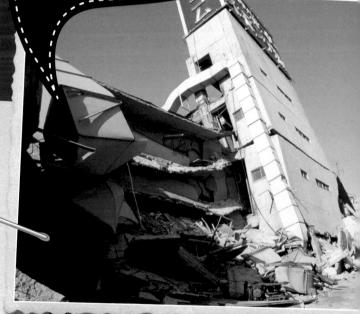

11

ver 93 per cent of Japan's people live in towns and cities - so it's not surprising that the biggest city in the world is here. Tokyo, Japan's capital, has a population of more than 37 million!

Towering Tokyo

One way to fit in a record-busting population is to build upwards! Tokyo is crammed with sleek, shiny skyscrapers and includes the world's tallest tower - the Tokyo Skytree, at 634m. Crowds of people swarm the orderly, neon-signed streets, while hidden from view in the heart of the city is the Emperor's Imperial Palace.

> Traffic stops and people go at Tokyo's famous Shibuya Crossing.

A High-rise apartments fit maximum numbers of people into minimum space on the ground.

TOKYO WAS ORIGINALLY CALLED EDO, MEANING 'ESTUARY', BECAUSE IT'S BUILT WHERE TWO RIVERS MEET THE SEA.

Osaka sprawl

Japan's second-largest city, Osaka, has merged with neighbouring Kobe and Kyoto to form one sprawling metropolitan area. More than 20 million people live here. It's a lively financial and business centre, where big names such as Sanyo and Panasonic have their headquarters.

Imagine sleeping in an air-conditioned cupboard - a capsule hotel is similar!

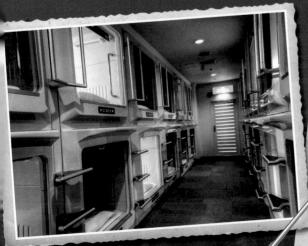

FOCUS ON

CITY LIVING

Flat land in Japan is hard to find, and cities fight for space on coastal plains around the mountains. Many built-up areas are growing and merging together, forming a belt along the southeast of Honshu that runs from Tokyo to Kobe. Vast numbers of people live in commuter towns or city suburbs, travelling to the city centre to work each day. Their homes are usually small, one-family or one-person apartments, and most people rent from a landlord or the company they work for.

Anyone who misses the last train home can grab a few hours of sleep in a cheap, tiny-roomed 'capsule hotel'.

HIGH-TECH TRAVEL

A jam-packed metro station in Tokyo.

Japan's transport system is about as modern as you can get. Roads are good, trains are super-fast and flights between cities are efficient. The main problems come when everyone wants to travel at once!

Bridges and tunnels

To get between Japan's main islands you don't have to go by boat. Several impressive bridges and tunnels cross the sea, including the world's longest suspension bridge and deepest railway tunnel. The Seikan tunnel connects Honshu with Hokkaido and lies 140m below the seabed!

TOKYO'S METRO SYSTEM

GETS SO CROWDED THAT OSHIYA.

OR 'PEOPLE PUSHERS', WORK TO

SQUEEZE PEOPLE ONTO

THE TRAINS!

The Akashi-Kalkyo suspension bridge looks like this from 300m up!

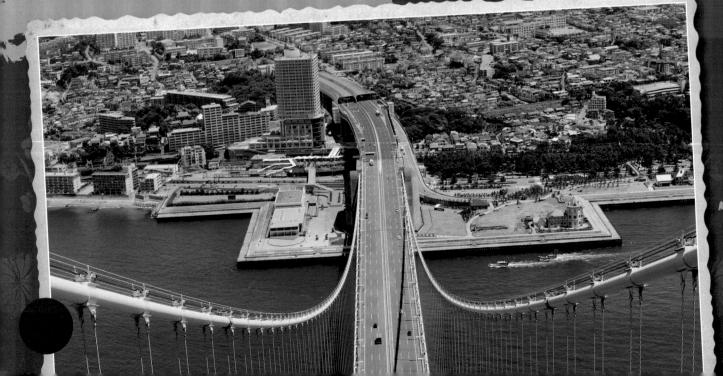

FOCUS ON

BULLET TRAINS

Blink and you might miss a Japanese bullet train, or Shinkansen — they reach speeds of up to 320km/hr! These futuristic trains run between major cities and are known for their punctuality and comfort. More than 300 trains travel a day, mostly on separate lines from ordinary commuter trains. All the seats face forwards and there are two classes of carriage. The train has a streamlined nose to help it move with minimal air resistance. Obviously it works — the average delay for a Shinkansen is less than a minute!

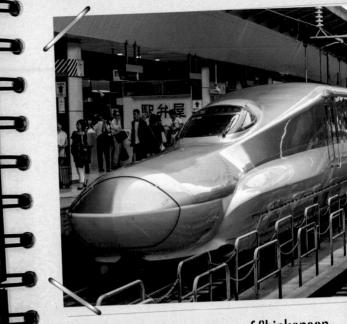

↑ There are three types of Shinkansen.

The fastest can zip from Tokyo to

Osaka in 2 hours 22 minutes – a trip

that used to take 7 hours!

You can hop from Osaka's island airport to the mainland by bus, train or boat.

Island airports

Where can you fit a set of airport runways in Japan?
When it came to building Kansai International Airport, engineers made a whole new artificial island! It lies in Osaka Bay and is linked to the mainland by a bridge. Japan has several other manmade island airports.

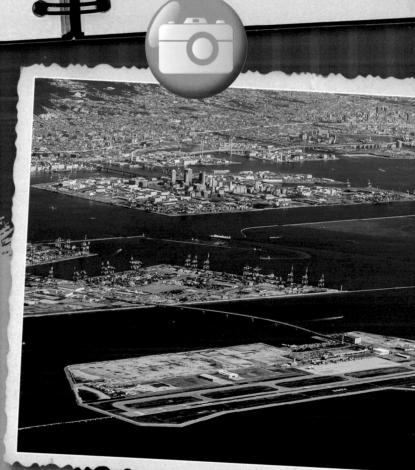

LIFE ON THE LAND

While Japanese cities buzz with crowds, in the countryside it's a different story. Job opportunities have driven people away from rural areas, and now less than 3 per cent of the workforce is employed in agriculture.

Chockablock crops

Barely 15 per cent of Japan's land is good for farming, but where it is, the crops are crammed in. Japan is almost self-sufficient in rice, which is grown in paddy fields on low plains or terraced slopes. Other popular crops in Japan include soybeans, wheat, barley, tea and a variety of fruits and vegetables.

Hokkaido's colourful flower fleids
have become a tourist attraction.

Rice takes up over half of Japan's farmland.

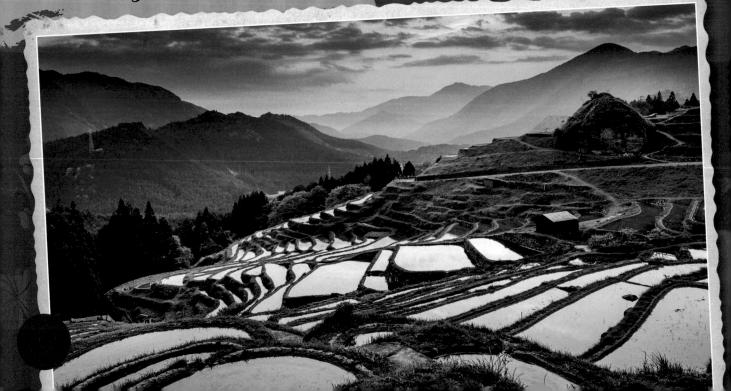

Food for the world

Japan sells many of its farm products abroad, especially to Hong Kong, the USA and Taiwan. Among the most popular exports are seasonings such as shouu (sou sauce) and miso (fermented sou paste), fruits including mandarins and apples, and expensive waquu beef.

WAGYU CATTLE ARE FAMED FOR BEING FED WITH BEER AND MASSAGED WITH RICE WINE CALLED SAKE!

harvest.

Japan's waqyu cattle tender, melt-in-the-

FOCUS ON

TIMES OF CHANGE

There are still farmers in Japan who grow their own food or sell it at local markets, but for most it's hard to make a living in this way. The majority of farmers do other jobs too, to help support their families. There's an ageing rural workforce as younger generations are reluctant to go into farming — but some young people are taking on the challenge and thinking of new ways to make farming pay. Setting up farmers' markets, producing readymeals and inviting tourists on farm-stays are a few new enterprises. There are also a growing number of urban farms, for example growing vegetables on train station roofs!

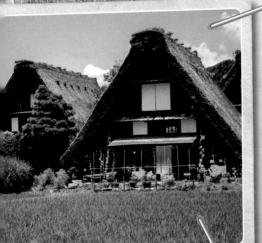

Traditional Gassho-style farmhouses like these have become a popular tourist attraction in Japan.

For a wealthy country with high standards of living, Japan has relatively few natural resources. It makes the best of what it's got, but is one of the world's biggest importers of food and energy.

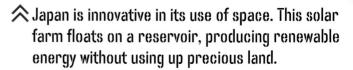

Generating power

With virtually no fossil fuel reserves, Japan imports a lot of coal, oil and gas. Before the Fukushima meltdown (see p11), about a third of the country's energy came from nuclear power, but reactors were closed after the disaster. Most of Japan's renewable energy comes from hydropower dams on its fast-flowing rivers.

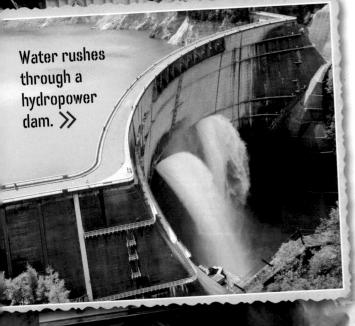

>> Tokyo is home to the biggest fish market
on Earth, selling about 450 varieties!

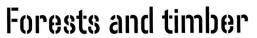

Although forests cover about twothirds of Japan, its forestry industry is small. Cheap prices abroad make imports a better option, and Japan buys in more wood, pulp and paper products than most other countries. A lot of these come from East Asia, where illegal logging and deforestation are a problem.

THE JAPANESE EAT

ABOUT 30KG OF FISH PER PERSON PER YEAR.

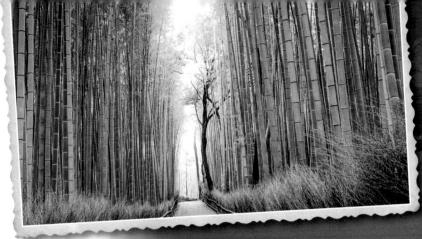

 This bamboo forest in Kyoto is a popular tourist attraction. Bamboo is a symbol of strength in Japan, and **Buddhist temples and Shinto shrines** are often built near bamboo groves.

FOCUS ON FISHING

Japan has so much sea on its doorstep that fishing has long been big business here. Fish is a major feature on Japanese menus, and the country is one of the world's largest consumers of fish and seafood products. Some of the most popular are bluefin tuna and eel, but their numbers are dwindling because so many have been caught. The Fukushima disaster had a big impact on the fishing industry too, as have changing diets as Japan turns more to Western food. Nevertheless, fishing is still important to coastal communities and aquaculture

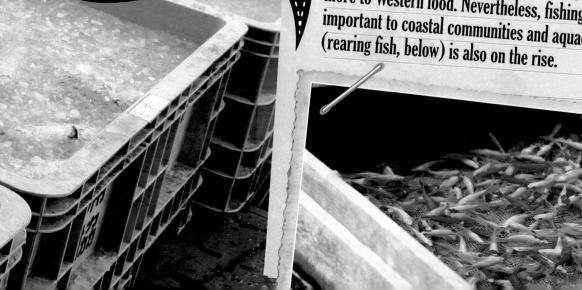

WILD JAPAN

From icy mountains to tropical rainforests, Japan has a wide range of habitats. Many creatures that live here are endemic, meaning they're found nowhere else on Earth.

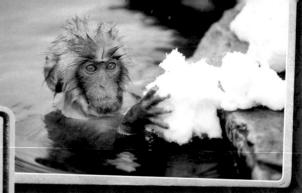

Snow monkeys

Japanese macaques can live further north than any other monkeys in th world. When temperatures sink below zero, they like to roll snowba and warm up in hot springs!

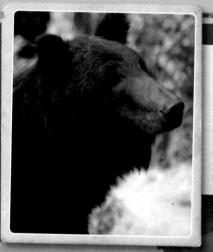

Big bears

Japan's largest mammal is the Ussuri brown bear – also known as the black grizzly. It's not to be confused with the Asiatic black bear, which has a white v-shaped marking on its chest.

Dancing cranes Sometimes described as 'snow

Sometimes described as 'snow ballerinas', Japanese redcrowned cranes are tall and graceful birds. You might see them walking and pecking in marshes or paddy fields, or performing an elegant dance to impress a mate.

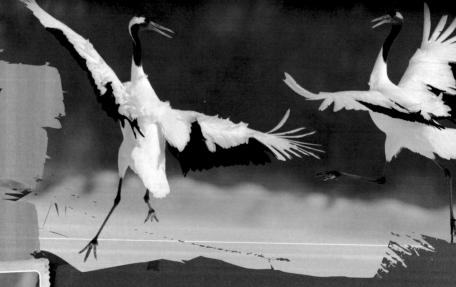

Goat-antelope

Imagine a goat mixed with an antelope, and you'll get something like the Japanese serow! This hairy forest-dweller is a national emblem of Japan and is found on three of the four main islands.

Deadly snake

Japan has many types of snake, but only three are venomous. The deadliest is the mamushi pit viper – a camouflaged creature that lurks among leaves, then darts out to ambush its prey.

THE ENVIRONMENT

When Japan began to industrialise in the late 1800s, its natural environments suffered. Pollution from factories and habitat loss meant that many types of animal became endangered or died out. Since the 1970s, the country has been cleaning up its act and its cities are now some of the lowest polluters in the world. But Japan continues to build dams and sea defences and expand its urban areas, all of which threaten wildlife. Acid rain from pollution across the sea in China is also a problem.

SHORT LIFESPAN OF JUST 7-10 DAYS. THE BEST MONTHS TO SEE THEM IN JAPAN ARE JUNE AND JULY.

Flashing fliers

You know summer has arrived when Japan's hotaru, or fireflies, start to swarm! People love to go out at night and view these glowing bugs, which flash light at each other to communicate.

Royal flower

The chrysanthemum is the symbol of Japan's Emperor and his family. The throne is named after it, and a chrysanthemum crest appears on imperial flags, shrines (right) and even battleships.

AMAZING INNOVATIONS

There's every chance you own something made in Japan!
This innovative country churns out cutting-edge technology round the clock, and its big-name brands are famous worldwide.

★ Tokyo's 'Electric Town' is a hub of electronics stores.

Big wheels

Japanese vehicles are a familiar sight on many countries' roads. Toyota is the world's largest car maker, and Nissan, Honda, Suzuki and Mazda aren't far behind. Japan is developing self-drive cars, solar cars and other eco-vehicles that could shape the future of travel.

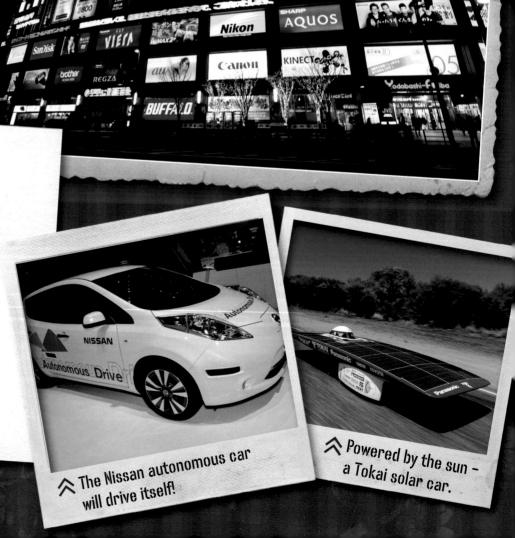

Excellent electronics

Sony, Panasonic, Toshiba, Hitachi, Canon, Nintendo – they all come from Japan! You can rely on them for brand new technology, and the latest developments on anything from cameras and smartphones to games consoles and TVs.

With a head-mounted display glass you can watch videos up close!

Inventing the 'unuseless'

Japanese invention isn't all serious.
Chindogu is the art of creating
'unuseless' solutions to everyday
problems – if you really need it or
end up using it, it doesn't count!
Examples of chindogu include sweep
shoes (with a dustpan and brush
attached) and the chopstick fan
(clips on to chopsticks to cool
down your food).

Robots get to work in a car factory. IN JAPAN'S AUTOMOTIVE INDUSTRY, AROUND 1,600 WORKERS IN EVERY 10,000 ARE ROBOTS!

FOCUS ON

ROBOT WORLD

Most of the companies mentioned here have a hand in devising robots — humanoid, animal, industrial, you name it. Look out for robot housekeepers, shop assistants, factory workers, astronauts... even

schoolteachers! In 2015, the first robot-staffed hotel opened at a Japanese theme park. Care robots include one by Panasonic that changes from a bed to a wheelchair. Robots are also being developed to perform surgery, work in disaster recovery and explore space. There are even factories in Japan where robots build other robots!

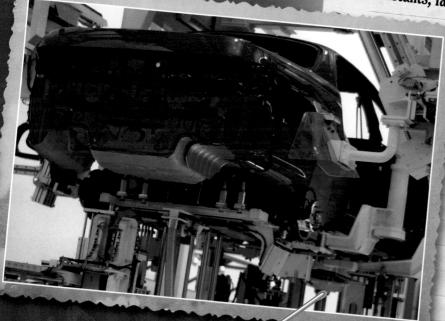

TRADITIONAL CUSTOMS

There are many types of bow in Japan, ranging from a simple ned to a deep bend at the waist. They mean different things, but they're always polite!

The Japanese may have a futuristic outlook, but they still cling to age-old traditions. One of these is bowing when greeting someone, which shows the importance of honour and respect.

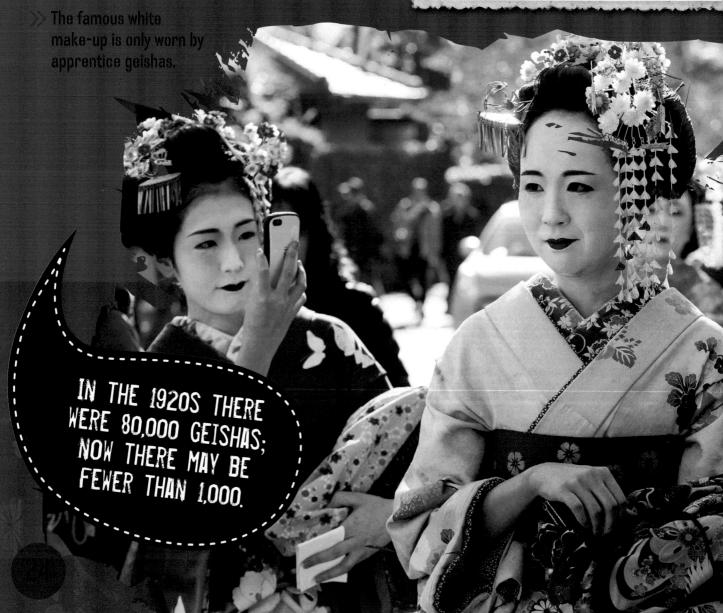

Ikebana

Flower arranging, or ikebana, has been an art form in Japan for centuries. It's all about feeling close to nature and working in silence to appreciate it. People choose their flowers, stems and leaves very carefully, arranging them in a way that creates harmony with their surroundings.

kebana emphasises the graceful lines and shapes of stems, leaves and blooms.

Chanoyu - the tea ceremony

Preparing and serving green tea for guests is a ritual in Japan. The idea is to welcome your visitors and treasure every moment of the experience. The host performs a routine of movements, placing everything in a certain way. Before drinking the tea, guests are given sweets to counter the bitter taste.

FOCUS ON

GEISHAS

Geishas are a type of female artist-entertainer, once hugely popular in Japan. Now there are far fewer of them, and they perform mainly for tourists and businessmen. Geishas train intensively from a young age, mastering skills in music, dance, art, poetry, the tea ceremony, flower arranging and conversation. They learn how to select and wear precious kimonos, create elaborate hairstyles and paint their faces white. One important aspect of being a geisha is mystery and intrigue, and the girls were traditionally highly paid as companions to wealthy men.

ALL SORTS OF SPORTS

Japan's hundreds of ski resorts receive an average of 10 to 18m of snow each season.

Japan is well known for its sumo and judo (see pp28-29), but the favourite sport here is baseball! The Japanese enjoy loads of other sports too, from football and golf to skiing and surfing.

Baseball bonanza

Japan is yakyu (baseball) crazy! Children play it from an early age, and the best go on to compete on national TV in the All-Japan High School Baseball Championship. Japan's professional baseball leagues are incredibly popular, with big companies sponsoring the teams. The end-of-season play-offs are some of the most exciting events of the year.

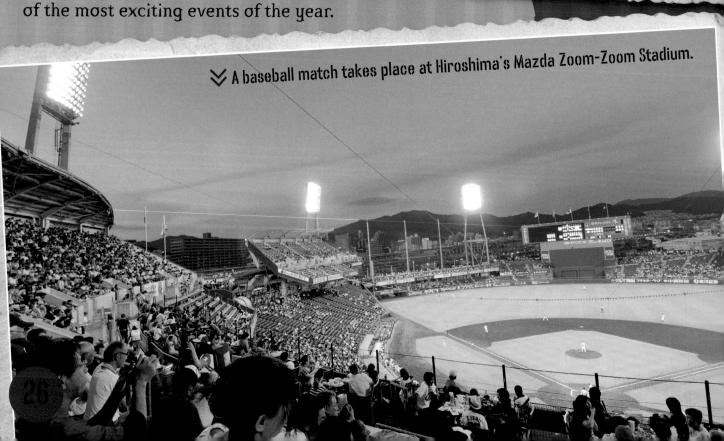

Japanese football

Football comes hot on the heels of baseball in Japan. Teams compete in the popular J-league, and many players have moved to European leagues too. The national team, the 'Samurai Blue', has qualified for the last five FIFA World Cups. There's also a strong women's side, who won the Women's World Cup in 2011 and silver at the 2012 Olympics.

> The Japanese women's football team celebrate their semi-final win at the 2012 Olympics.

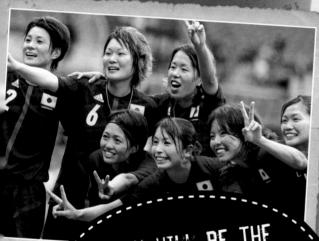

JAPAN WILL BE THE FIRST ASIAN COUNTRY TO HOST THE OLYMPICS TWICE.

Fans show their delight as they hear the announcment that Toyko has been chosen to host the 2020 Olympic Games.

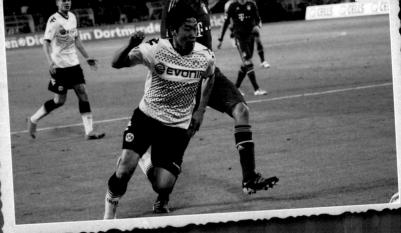

Shinji Kagawa is one of Japan's top football players.

FOCUS ON

TOKYO 2020

Japan has competed in almost every Olympic Games since it first took part in 1912! The Games have been held here three times — in Summer 1964, Winter 1972 and Winter 1998 — and in 2020, the Summer Olympics will return to Tokyo. The Japanese government has set aside 400 billion yen (over US\$3 billion) to cover the cost of building and upgrading stadiums, transport links and other facilities. The Japanese are regular Olympic medal winners in their home-grown sport of judo, and also in gymnastics, wrestling and swimming.

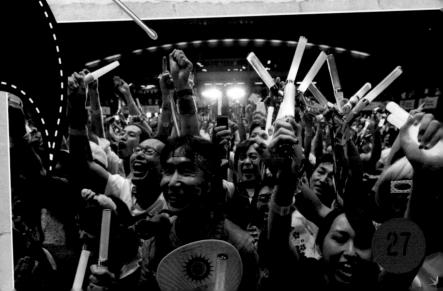

MARTIAL ARTS

ext time you watch someone doing Yjudo, think of them as a samurai warrior! Japanese martial arts began many centuries ago, when soldiers learned to fight with swords or no weapons at all.

> A black belt indicates the highest level of skill in martial arts.

Gentle Jujutsu

The key to jujutsu is using your opponent's weight against them, to throw them over or unbalance them. This ancient idea has developed into a range of popular martial arts, including judo and aikido. Players are unarmed and wear loose-fitting 'pyjamas', tied at the waist with a belt.

႙ Judo is an Olympic sport.

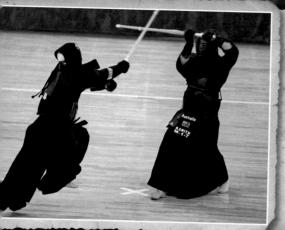

'The way of the sword'

When samurais practised swordsmanship, or kenjutsu, they used a deadly katana knife. Today's version, kendo, involves a sword made of bamboo or wood. Players wear masks and armour to protect themselves as they fight. To win, you have to strike the other player on the head or chest.

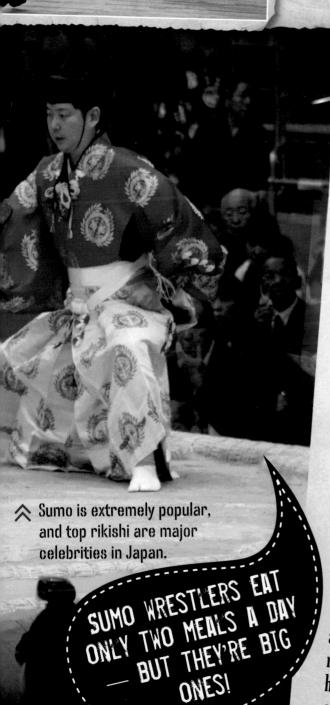

Sumo salt-tossing has its roots in the Shinto religion.

FOCUS ON SUMO

The national sport of Japan is a battle between two enormous, near-naked wrestlers! Known as sumo, it began in ancient times but flourished in the imperial courts of the 1600s. Sumo wrestlers, called rikishi, wear coloured loincloths (mawashi) and can weigh over 200kg. Before a match, they perform a series of symbolic rituals, including a ring-entering ceremony and tossing salt to purify the ground. Then each rikishi tries to barge the other out of the ring or trip him over. Matches usually last for just a few seconds, or minutes at the most!

GROWING UP IN JAPAN

Families tend to be small in Japan, with just two generations per household. Traditionally the mother looks after the children while the father works, though more women now are going out to work.

School slog

The Japanese see education as the key to success, and schools are really competitive. Pupils work long days and take regular high-pressure tests. Most children continue with high school when their compulsory education is over. Some go to cram schools, called juku, to prepare for exams or get extra help with their studies.

- Many children join after-school clubs or teams.
- Schoolchildren in Tokyo gather at the start of the spring term.

Ancient religions

Nearly 80 per cent of Japanese people believe in Shinto, an ancient religion that's unique to this country. They worship spirits called kami, which include things in nature such as the wind, rain, rocks and trees. Many people combine Shinto with Buddhism, Japan's next biggest faith.

>> A Buddhist priest hands out good luck charms.

IN JAPAN PEOPLE SHOWER BEFORE THEY BATH, LEAVING THE BATHWATER CLEAN SO THAT OTHERS CAN USE IT.

Most Japanese choose a Shinto wedding (below) and a Buddhist funeral, to show their respect to both religions.

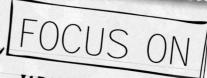

✓ Japan has tens

of thousands of

Shinto shrines.

JAPANESE HOMES

If you step into a Japanese home, remember to take your shoes off! There's usually an entrance area, called the genkan, where you leave them and put on house slippers. Most homes, even those in modern apartment blocks, include a traditional washitu room too. Here the floor is covered in tatami (rice straw) mats, and a sliding paper door called a shoji divides different areas. Furniture includes a low table and cushions on the floor, and a futon might be rolled out at night for sleeping. The bathroom is seen as a separate part of the house, where you put on a different pair of slippers.

★ Tea is laid out in the washitsu room.

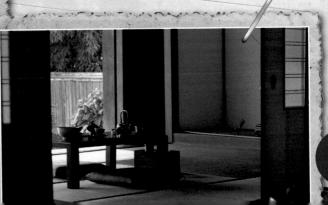

GET THE LOOK

The Japanese love everything up-to-the-minute – and this is true of their fashions too. Young people in particular are image-conscious and never far from the latest trends.

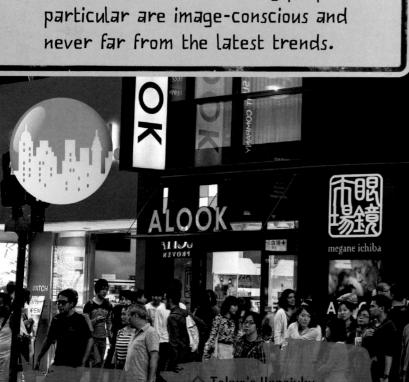

Tokyo's Harajuku district is like a giant outdoor catwalk!

Big buyers

Japan's big cities all have glitzy shopping streets, lined with international brands. Young customers with an eye for design make this one of the hottest fashion markets in the world. Fashion magazines are a popular way for teenagers to get ideas. The cosmetics industry does well here too.

Shiseldo is Japan's higgest cosmetic brand.

FOCUS ON

STREET STYLE

Japan's streets see such a fast-changing mass of fashion crazes that it can be hard to keep up. Many young people go for a quirky mismatch of different styles and looks. Kawaii is the Japanese term for all things super-cute, and it pitches up in trends like the Sweet Lolita 'doll' look — all ribbons, bows, ruffled petticoats and bloomers. Kawaii kids choose pastel or neon colours, even down to pink or green hair. The style has gone global among the under-25s — in 2014 the word kawaii was added to the Collins English dictionary.

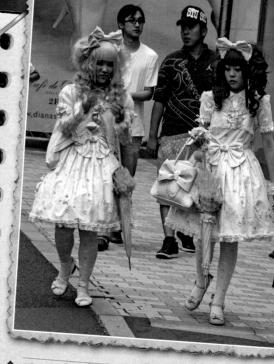

in Wonderland and Victorian Britain!

COSPLAY IS THE JAPANESE TREND OF DRESSING LIKE YOUR FAVOURITE CARTOON OR GAMING CHARACTER!

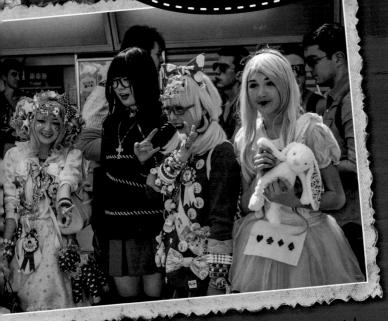

You've got to be quirky to carry off eosplay!

🕿 Japanese designer Yumi Katsura joins her models on the catwalk.

Designer names

Comme des Garçons might not sound Japanese, but it is! It's one of many successful fashion labels that have spread from this country around the world. Issey Miyake is probably the most famous Japanese fashion designer, while Uniqlo is known globally for its current. affordable clothes.

WORK AND LEISURE

Hard work and loyalty are deeply ingrained in the Japanese culture. People dedicate themselves to their jobs almost as much as to their family, putting pressure on their leisure time.

MANY JAPANESE COMPANIES
HAVE THEIR OWN SONGS, SUNG
BY WORKERS TO ENCOURAGE
TEAM SPIRIT!

Working hours

Japan is well known for its long working hours. These have begun to decrease in recent years, but nearly a quarter of Japanese workers still clock up 50+ hours a week, and some as many as 80. Leaving the office after 11pm is normal, and colleagues often socialise after hours.

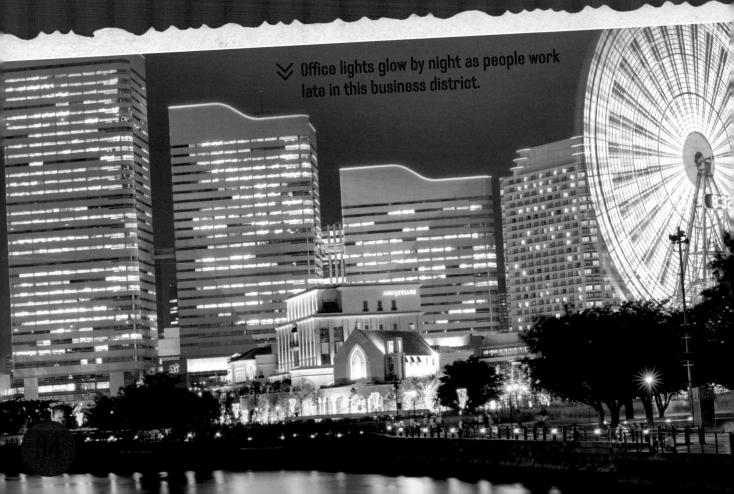

In the past, Japanese firms offered lifetime job security, in return for loyalty from their employees. This has changed a fair bit in the last decade, as economic problems forced businesses to lay off staff. People now change jobs more often, and many work part-time or on short-term contracts.

FOCUS ON

TIME OUT

While most people look forward to taking time off, in Japan it's rare for workers to use their full holiday allowance. Politicians are now looking to make five days off per year compulsory, to try to lessen the problems that people suffer through stress at work. In their leisure time, the Japanese enjoy things like dining out, playing pachinko (pinball) or relaxing in an onsen (hot spring). Those who have time — especially the retired generation — travel within Japan or abroad. More than 17 million Japanese tourists went overseas in 2013

A bubbling hot spring to one place to wind down after a long working week.

DATES TO CELEBRATE

Festivals, or matsuri, happen year-round in Japan - there are hundreds of thousands of them! Many are local events, based on a particular shrine or temple.

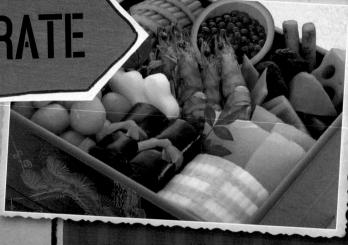

The traditional Shogatsu dish is osechi-ryori, served in a lacquered box

Shogatsu (New Year)

At midnight on New Year's Eve, Buddhist temples in Japan ring their bells 108 times. People celebrate for the next three days, eating special foods, visiting shrines and temples and giving children gifts of money.

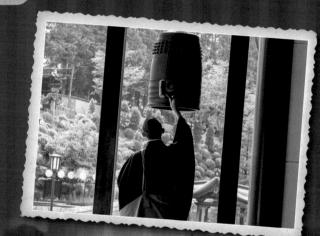

Coming of Age Day

The second Monday of January celebrates everyone who has turned 20 over the past year. Girls dress in beautiful kimonos and slippers, and boys in smart suits. They visit shrines and party with their friends and families.

Hanami

From March to early May, Japan's famous cherry blossoms (sakura) burst into bloom. News reports tell people the best places to see them, and families hold parties among the trees.

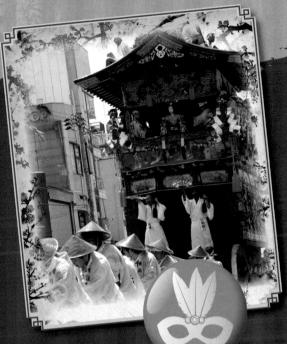

Gion Matsuri

In Kyoto, the month of July is dedicated to Gion Matsuri. The highlight of this historic festival is a grand parade of floats, known as 'Yamaboko Junko'.

When 7 July arrives, people all around Japan write wishes on narrow strips of coloured paper and hang them on trees and in the streets. This tradition is based on a legend about two stars that meet just once a year.

Shichi-go-san

On 15 November, it's the turn of 3- and 7-year-old girls and 3- and 5-year-old boys to be honoured! People pray for their health at Shinto shrines, and parents buy chitose-ame, or 'thousand-year candy', to give to their children as a symbol of long life.

TASTES OF JAPAN

Japanese food tends to look good, taste good and be good for you!
People often eat at low tables, sitting on cushions on the floor, and it's good manners to finish every last grain of rice.

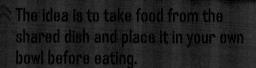

On the table

At a typical Japanese meal, all the food is put out at once. Each person has a bowl of rice, chopsticks, and often some miso soup drunk straight from the bowl. There's a main dish of meat or fish, plus cooked or pickled vegetables and soy sauce. Other popular foods include noodles, yakitori (grilled chicken skewers) and sushi (see right).

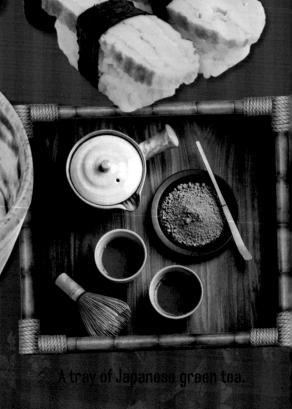

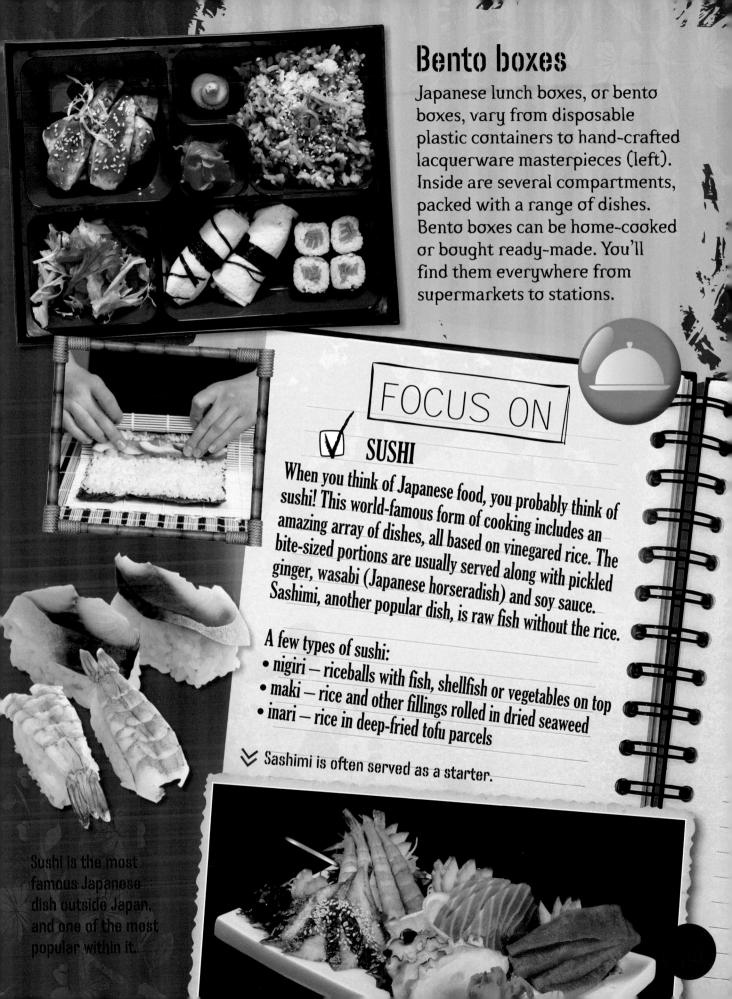

BORN TO PERFORM

The performing arts of Japan are a colourful mix of old and new. Some types of music and theatre have barely changed in the last 1,000 years, while others are ultra-modern.

Karaoke culture

You don't need to be a good singer to enjoy karaoke! It was invented by a Japanese musician in 1971 and has taken the world by storm. In Japan, the singing usually happens in private 'karaoke boxes', each equipped with music, a microphone and lyrics on a screen. People of all ages love it!

Traditional Japanese drummers perform at a festival.

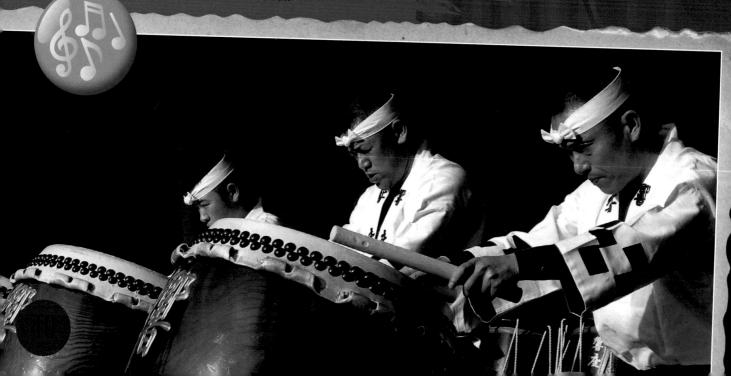

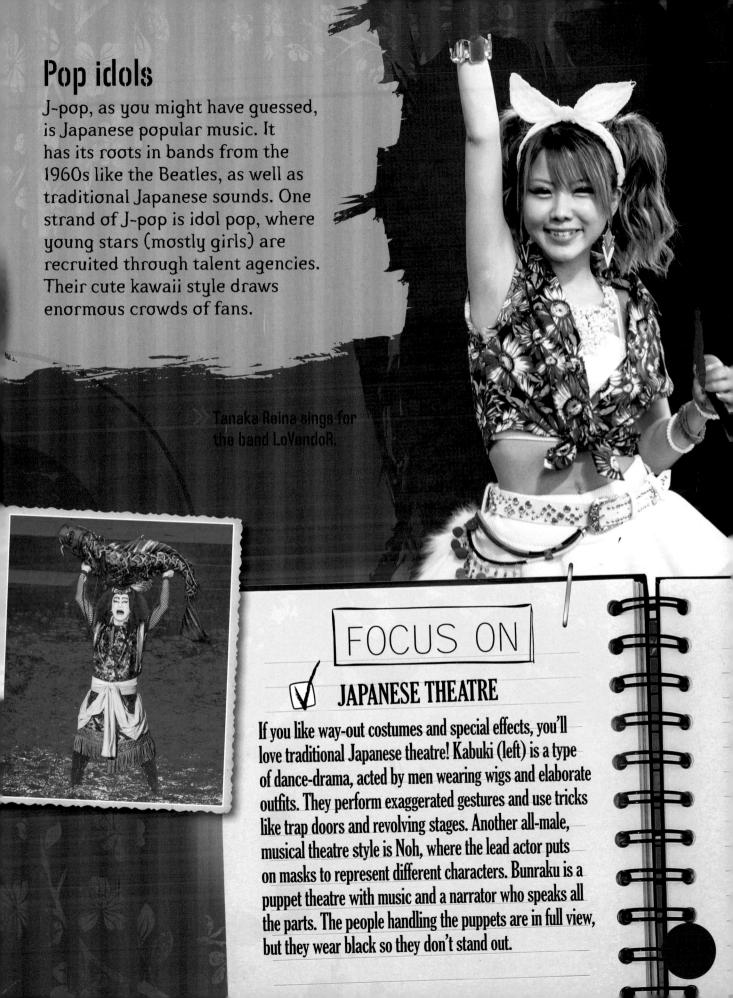

CREATIVE CULTURE

Japan is well known for its traditional arts, from calligraphy to origami. Blend them with modern manga and anime, and you get a buzzing creative scene that's catching eyes around the world!

Paper magic

Origami artists can fold a square of paper into an animal, a flower, a toy, a container or much more! This nimble-fingered Japanese art has developed over hundreds of years. One of the best-known origami shapes is the crane – in Japan, folding 1,000 paper cranes is thought to bring good health.

Two cranes done, 998 to go! \times \times \text{Writing calligraphy with a brush is an art form in itself − most Japanese children learn it at school.

IN 2009, 800 PEOPLE IN HIROSHIMA MADE AN ORIGAMI CRANE WITH A WINGSPAN OF 81.94M!

Origami is fun and rewarding to learn.

Woodcut prints

In the 1800s, the Japanese artists Hokusai and Hiroshige made famous a style called ukiyo-e. They carved decorative images into blocks of wood then printed them onto paper. The prints, often showing landscapes or scenes of life in Japan, had a big influence on modern European painting.

FOCUS ON MANGA & ANIME

If you've never read a manga comic, you probably know someone who has! Modern manga began in Japan in the 1900s, and is now a global hit. There are many styles of illustration, but one of the most popular shows characters with extra-large eyes or other exaggerated features. Another thing you'll notice is that you read the stories from back to front and right to left, just like Japanese writing. Manga in animated form is known as anime, and characters from the stories have also burst into the worlds of gaming, fashion, freebie toys and other merchandising (right).

apan has faced some huge challenges in recent years, with crippling natural disasters and recession. But its economy is growing, and winning the Olympic bid has helped to cheer people up.

Getting old

Japan has one of the highest life expectancies in the world, but also a very low birth rate. This means that the population is both decreasing and ageing rapidly, and there aren't enough young people to provide for the old. More than a quarter of the population is over 65, and this is set to reach a third by 2035.

★ Tokyo will play host to millions of visitors during the 2020 Olympics

Care robots are becoming a flourishing industry as the population ages.

ON AVERAGE, WOMEN IN JAPAN LIVE TO 87, AND MEN TO THE AGE OF 80.

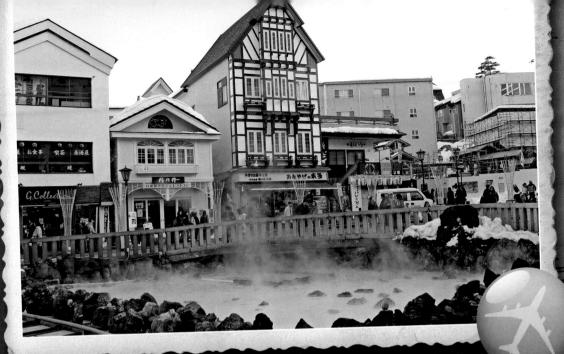

This hot spring resort is one of Japan's many tourist attractions..

Attracting visitors

More and more foreigners are visiting Japan, to explore its accumus scenery and take in the fascinating culture. Over 13 million tourists are lived in 2014, and the goal is for 20 million per year by the Tokyo 2020. Otherwise. The money they spend is helping to boost Japan's economy.

FOCUS ON

LOOKING AHEAD

Japan is a small country, but it plays a big part on our planet. Although it faces strong competition from countries like China, it is still a powerful economy — the third largest in the world. It has shown amazing resourcefulness in dealing with massive disasters, such as the 2011 earthquake and tsunami. Japan has good relations with other nations, helping it to secure vital imports of food and energy and trade its own exports around the globe. Opening up to more foreign immigrants may be one way to tackle the problem of the country's ageing workforce.

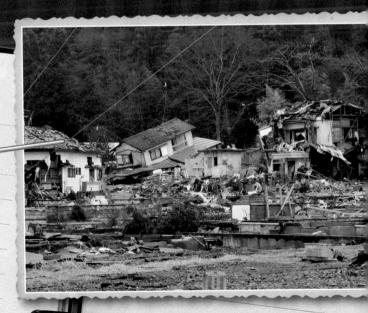

Recovering from tsunami damage like this takes many years.

QUIZ

How much do you know about Japan's land and people? Try this quick quiz and find out!

1 What is the capital of Japan?

- .a) Osaka
- b) Tokyo
- c) Kyoto

2 What is the Japanese currency?

- a) Euro
- b) Dinar
- c) Yen

3 Which of these volcanoes is in Japan?

- a) Vesuvius
- b) Fuji
- c) Krakatoa

4 Which Japanese theatre style involves puppets?

- a) Noh
- b) Kabuki
- c) Bunraku

5 What is a Shinkansen?

- a) A hot spring
- b) A bullet train
 - c) A type of robot

6 What is Japan's favourite sport?

- a) Karate
- b) Baseball
- c) Football

7 Which flower is the symbol of the Japanese Emperor?

- a) Lotus
- b) Lily
- c) Chrysanthemum

8 What is the name of the traditional Japanese straw mat?

- a) Tatami
- b) Washitsu
- c) Mawashi

9 What is ikebana?

- a) A tea ceremony
- b) A style of music
- c) Flower arranging

10 What is tossed on the ground before a sumo match?

- a) Sand
 - b) Salt
 - c) Rice

11 Which is Japan's biggest island?

- a) Honshu
- b) Hokkaido
- c) Shikoku

12 What is sashimi?

- a) Expensive beef
- b) Raw fish
- c) Soy sauce

True or false?

- 1) More Japanese people live in cities than the countryside.
- 2) Sumo wrestlers eat eight meals a day.
- 3) The Japanese serow is a deadly snake.

GLOSSARY

atomic bomb
A highly destructive
weapon that explodes
using nuclear energy.

Damboo A type of woody grass

camouflaged Blending in with particular surroundings.

clan A group of interrelated families.

deforestation
Clearing an area of forest
or trees.

democracy
A country that is governed
by elected leaders.

estuary

The mouth of a large river, where it meets the ocean tide

evacuate

To move people from a place of danger to somewhere safe

exports

Goods or services that are sold abroad.

extinct

volcano One that has not erupted for at least 10,000 years and is not expected to erupt again.

humanoid Resembling a human being

hydropower
Energy generated by water
rushing through turbines.

ice age

A long period in Earth's history when ice covered much of the planet.

immigrant

A person who arrives in a place to live.

imports

Goods or services that are bought in from abroad.

innovative

Original or inventive, involving new ideas.

lacquerware

Decorative items, usually made of wood, that have been coated with lacquer, a type of varnish.

landslide

A mass of earth or rock that collapses from a mountain or cliff.

life expectancy

The average age people are expected to live to.

recession

A period when the economy suffers.

rura

Relating to the countryside as

shrine

A structure that marks a holy or sacred place.

tsunam

A series of large, powerful ocean waves, usually the result of an earthquake.

urban

Relating to towns or cities.

Further information

Books

Countries in Our World: Japan by Jim Pipe (Franklin Watts, 2011)

Fearless Warriors: Samurai by Rupert Matthews (Franklin Watts, 2016)

Planet in Peril: Tsunami Surges by Cath Senker (Wayland, 2015)

The Where on Earth? Book of Volcanoes and Earthquakes by Susie Brooks (Wayland, 2016) Catastrophe! Earthquake Disasters by John Hawkins (Franklin Watts, 2014)

Websites

www.lonelyplanet.com/japan A detailed travel guide to Japan.

web-japan.org/kidsweb
Explore Japan and its culture.
www.infoplease.com/science/
weather/japan-tsunami-2011.
html

Info about the 2011 earthquake and tsunami. www.japan-guide.com
Plan your Japan trip here!

Index

acid rain 21
ageing 17, 44, 45
agriculture 16
airports 15
anime 43
aquaculture 19
archery 7
area 4
artists 43
Asia 4, 7, 19
atomic bombs 7

bento boxes 39 birth rate 44 bowing 24 brands 22, 32 bridges 14, 15 bullet train 5, 15

calligraphy 42
capital city (Tokyo) 4, 12,
13, 27, 45
'capsule hotels' 13
children 26, 30, 36, 37
chopsticks 4, 38
chrysanthemum 21
cities 4, 12, 13, 14, 15,
16, 21, 32
Hiroshima 7, 42
Kohe 13

chrysanthemum 21
cities 4, 12, 13, 14, 15,
16, 21, 32
Hiroshima 7, 42
Kobe 13
Kyoto 13, 37
Nagasaki 7
Osaka 13
city suburbs 13
climate 9
coastline 9, 11
commuters 13, 15
cosmetics industry 32
cosplay 33
countryside 16
creatures 20

currency 4

dams 18, 21 deforestation 19 democracy 7 disasters 11, 44, 45

earthquake-resistant
buildings 11
earthquakes 10, 11, 45
economy 11, 44, 45
eco-vehicles 22
education 30
emperors 6, 7, 21
Akihito 6
Hirohito 6, 7
Meiji 7
energy 18, 45
evacuation drills 11
exports 17, 45

families 30, 34, 36, 37
farming 16, 17
fashion 32, 33, 43
festivals 36, 37
first settlers 6
fishing 6, 19
floods 9
flower arranging 25
food 17, 18, 38, 39, 45
forests 19
Fukushima nuclear power
plant 11, 18, 19
furniture 31

gaming 43 geishas 24, 25 gorges 9

habitats 20 highest peak 4 homes 13, 31 hot springs 20, 35 hunting and gathering 6

idol pop 41 illegal logging 19 imports 18, 19, 45 inventions 23 islands 5, 8, 9, 14, 15 Hokkaido 5, 8, 14 Honshu 5, 8, 13, 14 Kyushu 4, 8 Shikoku 4, 8

Jomun culture 6

karaoke 40 kawaii 33, 41

lakes 9 landslides 9 language 4 leisure time 34, 35 life expectancy 44

manga 43 marshes 20 martial arts 7, 28 military 7 Miyake, Issey 7, 33 monsoon 9 mountains 8, 9, 20 Mount Fuji 4, 5, 8 music 40, 41

natural resources 18 nature 4, 25, 31 nuclear power 11, 18

Olympic Games 27, 45 Ono, Yoko 7 origami 42

Pacific Ocean 10 paddy fields 16, 20 performing arts 40 pollution 21 population 4, 12, 44

radiation 11 rainforests 20 recession 44 religions 4, 31, 36, 37 Buddhism 6, 31, 36 Shinto 4, 31, 37 renewable energy 18 rice 16, 38, 39 Ring of Fire 10 rivers 9, 12, 18 robots 4, 5, 23, 44

samural warriors 7, 28, 29 schools 30 shoguns 7 shrines 4, 21, 36, 37 skiing 5, 26 skyscrapers 4, 12 snowboarding 5 sport 26, 27, 29 sumo 29 sushi 5, 38, 39 Suzuki, Ichiro 7

tea ceremonies 4, 25
technology 4, 22, 23
temples 36
theatre 40, 41
tourists 13,17, 25, 35, 45
towns 12
traditional arts 42
traditions 4, 24, 37
trains 4, 5, 13, 14, 39
transport system 14
tsunamis 11, 45
tunnels 14
typhoons 9

vehicles 22 volcanoes 4, 8, 9, 10

wagyu beef 17 washitu room 31 waterfalls 9 wildlife 21 workforce 16, 17, 45 working hours 34

Yamato clan 6 Yayoi 6

crops 16